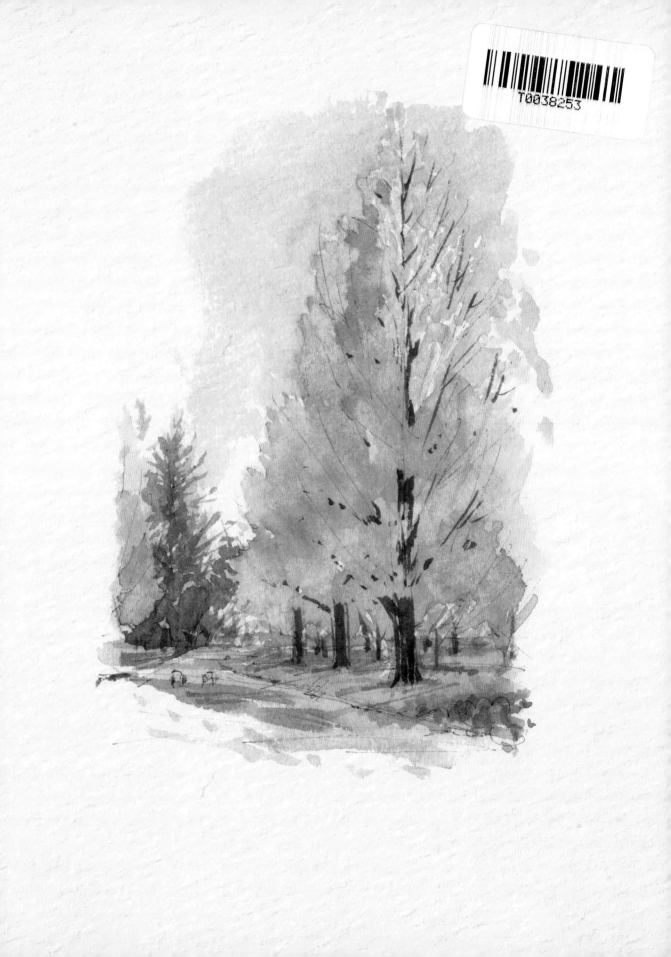
T0038253

A BEGINNER'S GUIDE TO
WATERCOLOR PAINTING

TAKAKO Y. MIYOSHI

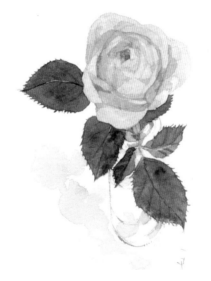

TUTTLE Publishing

Tokyo | Rutland, Vermont | Singapore

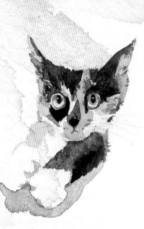

Contents

CHAPTER 2 Try Painting Familiar Subjects

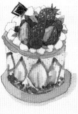
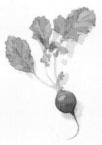

CHAPTER 3 Painting Landscapes

**APPENDIX: CUT-OUT WATERCOLOR
 SKETCH POSTCARDS**

16 designs

Why I Wrote This Book

Watercolor painting is, as the name suggests, paintings that are created by using water colored with paint, which is then applied freely to paper. Sketching, on the other hand, is to draw quickly and casually, creating a rough drawing within a short period of time, capturing what you feel. "Watercolor sketching" is thus an expressive technique accessible not only to beginners but also to those who may feel they are not very good at painting—all one needs to get started is paper, paint, brushes and water.

Although sketching may seem a little difficult, that is usually because painters feel the pressure to depict everything exactly as they see it and end up trying too hard. Instead, consider painting only the parts you like, however you like! Doesn't that sound like more fun?

For example, in a landscape, you can omit a difficult building, or in the case of a cake, you can zoom in on the strawberry, or if it is a cat, you can change its pose to make it easier to paint.

Transparent watercolor paints can be used to express a full spectrum of beautiful colors using only 12 basic colors and a few other specialized colors. A watercolor brush pen is convenient for producing watercolor sketches while traveling or spending time outdoors.

Using the art materials introduced in this book, I walk you through how to paint familiar subjects to cover the key techniques and tips for watercolor sketching. While there is no definitive method when it comes to watercolor painting, getting a lot of practice at painting and, more importantly, enjoying yourself while doing so, is the secret to improving.

First, pick up a paintbrush. Then, try applying the colors you like on paper!

Enjoy the wonderful world of watercolor sketching!

—Takako Y. Miyoshi

How to Use This Book

Color Names

The colors and color names vary depending on the manufacturer, but in this book all the watercolor sketches have been created using the following 18 colors.

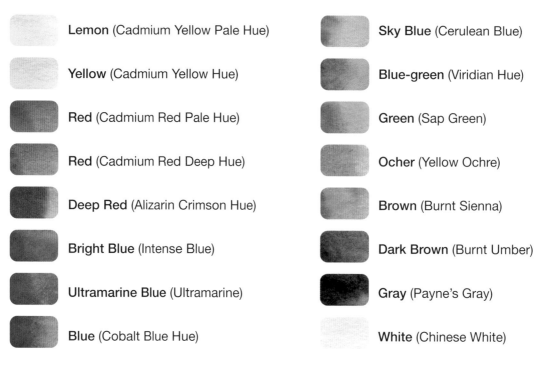

Lemon (Cadmium Yellow Pale Hue)

Yellow (Cadmium Yellow Hue)

Red (Cadmium Red Pale Hue)

Red (Cadmium Red Deep Hue)

Deep Red (Alizarin Crimson Hue)

Bright Blue (Intense Blue)

Ultramarine Blue (Ultramarine)

Blue (Cobalt Blue Hue)

Sky Blue (Cerulean Blue)

Blue-green (Viridian Hue)

Green (Sap Green)

Ocher (Yellow Ochre)

Brown (Burnt Sienna)

Dark Brown (Burnt Umber)

Gray (Payne's Gray)

White (Chinese White)

▼In this book, two handy colors have been added to the basic set of 16 colors above.

Navy Blue (Indigo)

Pink (Opera Rose)

The paints used are Winsor & Newton Cotman series (pan type).

Notes

- Transparent watercolor paints are used.

- All the works are rendered on postcard-size paper (approx. 4 in × 6 in / 10 cm × 14.8 cm).

- The brushes used are all watercolor brush pens, but you can also enjoy sketching with regular watercolor brushes.

- Combined colors are those that are created by mixing paints together. The mixing is usually done on a palette.

- The density of the pigment is described as dilute or concentrated. Where there is no particular notation, use the density marked with ★ as a guide.

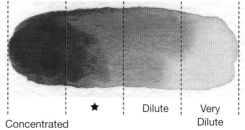

Concentrated ★ Dilute Very Dilute

CHAPTER 1
How to Get Started

Before you start making a watercolor sketch, you will want to prepare some basic equipment. Along with paints and brushes, there are some other tools that you will find useful. Use the ones introduced here as a reference.

The Materials Needed for Watercolor Sketching

Here is some watercolor sketching equipment that you will want to have on hand. The items are all available at art supply stores and stationery shops.

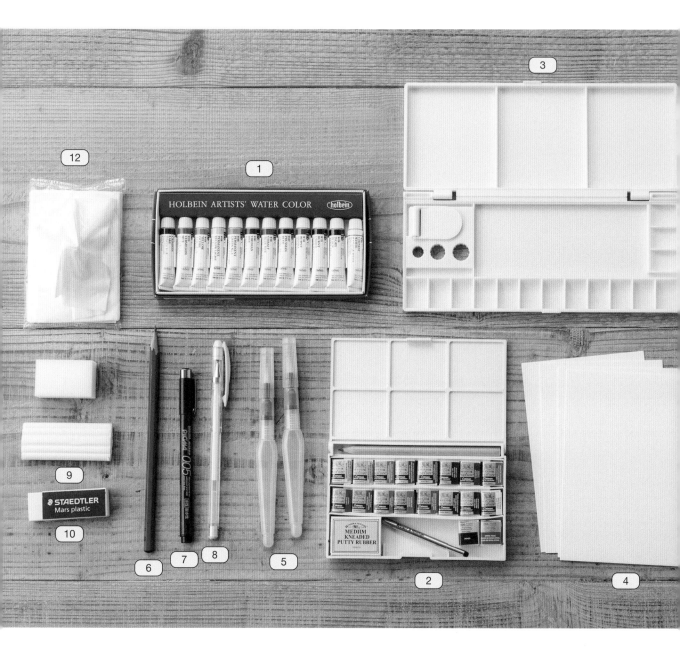

Transparent Watercolor Paints

Transparent watercolor paints are used by mixing them together to create colors, so you do not need a lot of different colors. I recommend starting with a set that has 12–24 well-balanced basic colors. The paints come in tubes or pans, but they can both be used as paint.

Tubes of Paint

These contain liquid paint. They can also be purchased separately as single colors or as a set.

Paint Blocks

These fit into the palette, so they are convenient to carry. The specifications differ between manufacturers but you can replenish or add colors.

3

Palette

I recommend one that is plastic and folds in half as it is light to carry and easy to clean.

4

Paper

This is watercolor paper cut to postcard size. The moisture will warp the paper, so choose a thick type. White Watson 300g is used in this book.

5

Watercolor Brush Pens

These are pen-style brushes that have a reservoir in the barrel to hold water. They come in a few basic sizes. The ones shown here are fine brushes, with tips that are 5 mm in diameter. It is useful to have two brushes on hand.

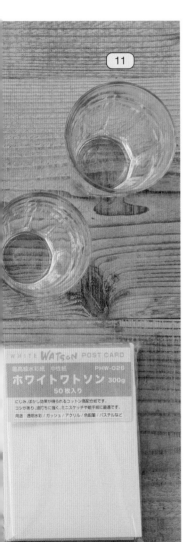

Pencil

I recommend either an HB or B pencil because if the lead is too hard, it will damage the paper.

Water-resistant Pen (water-based pigment ink)

This is used for adding details.
I recommend one with a fine tip, for example, 0.05 mm or 0.03 mm.

White Marker Pen (or a correction pen)

This is handy for adding highlights to areas covered with color.

Kneaded Eraser

This is an eraser that you knead with your fingers to soften it before use. Press down onto the pencil lines in a dabbing motion to erase them.

Plastic Eraser

This is a standard type of eraser. Use this when you want to cleanly erase lines. Take care not to use it too vigorously as it can easily damage the paper.

Brush Cups

It is useful to have two, one for washing the brush tips and the other for diluting paint. It is fine to use cups or glasses from the kitchen.

Tissue Paper

This is used to neaten the tip of the brush and remove excess water.

Preparing the Transparent Watercolor Paints and the Palette

What makes watercolor sketching easy is the handling of the paint. First, let us learn about the characteristics of transparent watercolor paints and how to put the paints in the palette.

The characteristics of transparent watercolor paints

The color underneath shows through

When you layer colors, they appear like overlapping colored cellophane where the color underneath shows through. A characteristic of this is a sense of transparency, as if the colors allow light to pass through them.

The color becomes lighter when dry

The color will become lighter when it is dry compared to when it is wet. When you prepare the colors in the palette, make them slightly more concentrated.

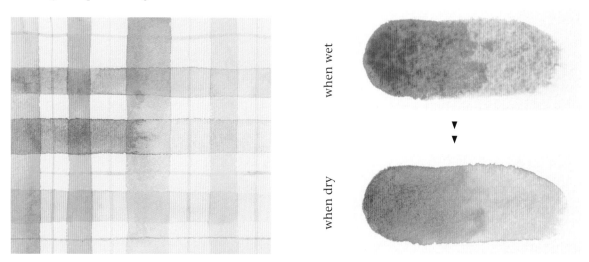

when wet

when dry

Using water to adjust the color shading

With opaque paints that are used for oil paintings and poster colors, white paint is added to lighten the colors, whereas with transparent watercolors water is used to create this effect, allowing the white of the paper to show through to varying degrees. When making the color samples (opposite), create single color gradations like the one on the right.

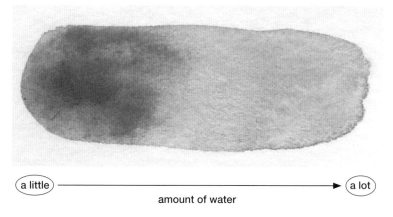

a little ——————————————→ a lot

amount of water

Adding the paints to the palette

Paint Tubes

Putting paint in the small compartments

Squeeze paint out of the tubes into the palette's small compartments. Load them in the same order that they're packaged, dispensing a small amount (about ⅖ in/1 cm in diameter). It is useful to dispense all the colors you have in the palette in advance, as even if the paints harden, they can still be used if you soften them with water.

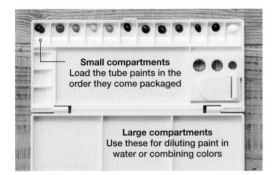

Small compartments
Load the tube paints in the order they come packaged

Large compartments
Use these for diluting paint in water or combining colors

Adding your favorite colors

Once you feel comfortable, add paints that are your favorite colors or colors that you often use to customize the palette and make it easier for you to use.

Taking care of your palette

In principle, you do not have to wash the whole palette. Use damp tissue to wipe away any paint remaining in the large compartments.

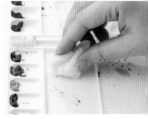

What to do if the paints you set in the palette get dirty

Using a watercolor brush pen, add a few drops of water to the paint to dissolve the unwanted paint, and then soak it up with a tissue.

Paint Pans

The paint is solidified into small blocks and can be used directly from the container.

Creating color samples

Check the colors of the paints

The color samples are tests of the paints on paper. Even with a single color like blue, there are many different hues and the shades also vary depending on the manufacturer. In addition, for transparent watercolor paints, the impression changes depending on whether the paint is solid or diluted in water, so always make color samples.

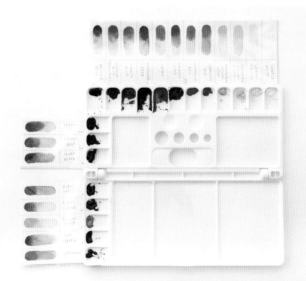

How to create color samples

1 **Prepare some paper and add color.**
Using watercolor paper, apply the colors in the order that they are set in the palette.

2 **Note the color name and number.**
If you write down the name and number of the color, it comes in handy when you want to buy additional paint.

3 **Attach them to the palette.**
If you match up the color samples with the paints in the palette and fix them in place, you can check the colors any time you want.

How to Use a Watercolor Brush Pen

If you know the basic way to use a watercolor brush pen,
you can enjoy watercolor sketching anytime, anywhere.

What is a watercolor brush pen?

This is a pen-style watercolor paintbrush with a barrel that you fill with water. It is used in the same way as a conventional paintbrush, but the water in the barrel can be used to dilute the paint or wash paint off the brush, making it ideal for sketching on the go. As it is made from plastic, it is also easy to clean.

One type of brush tip is round and can be used for a wide range of purposes, and another type is flat, making it good to use to cover broad surfaces. The shapes and sizes vary depending on the manufacturer, but in this book we use a large round brush tip.

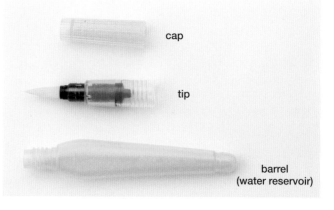

cap

tip

barrel
(water reservoir)

Filling the watercolor brush pen

Method 1:
Adding water directly

Method 2:
Squeeze submerged
barrel to draw up water

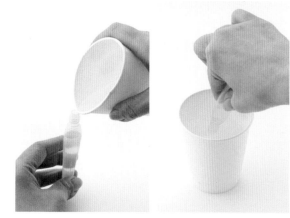

Remove the tip, put an appropriate amount of water in the barrel reservoir, and then replace the tip.

Holding the watercolor brush pen

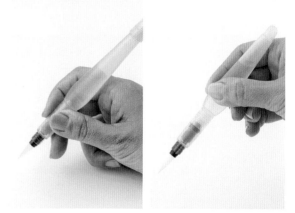

Hold the solid part above the tip and below the barrel as if you were holding a pencil. If you hold the soft reservoir part too tightly, water will come out, so be careful.

Adjusting the water and applying the paint

Releasing the water

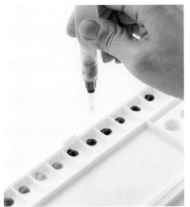

Water seeps out from the brush tip when you press on the barrel. If you press too hard, too much water will come out, so start by doing this over a dish to find out how hard you should press.

Applying the paint

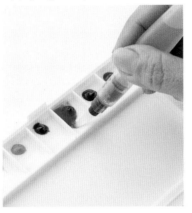

Press the barrel to dampen the tip and then add paint from the palette. Even if the paint is hard and does not soften right away, hold the tip of the brush gently on top of the paint for 5–10 seconds and then it will be fine to use.

Altering the concentration

To adjust the concentration of the paint on the palette, press the barrel to release the water and adjust it to your liking.

Changing the colors

Using the brush cup

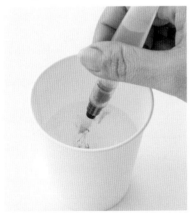

Soak the tip in the water and rinse the brush.

Using tissue instead of a brush cup

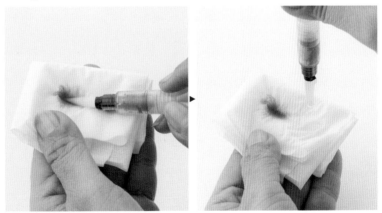

Press the soft part of the barrel to release water onto a tissue. Do this two or three times until color no longer shows on the tissue.

Expressions made possible with a watercolor brush pen

Thin straight lines

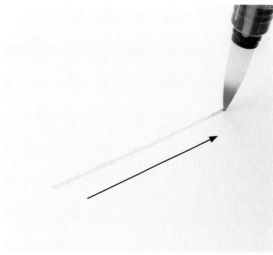

For fine, detailed areas, stand the brush upright to use it. Paint straight lines by moving the brush in a single stroke with a sliding motion. When painting long lines, try lifting your wrist.

Thick straight lines

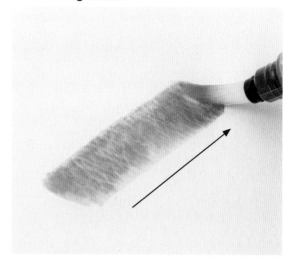

Lay the brush slightly down toward you and use the side of the tip to paint in one motion.

Coloring large areas

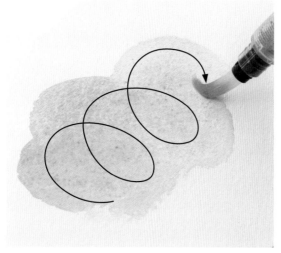

Lay the barrel slightly down toward you and have the entire side of the tip touch the paper. Move the brush in a circular motion.

Creating blurring and smudging

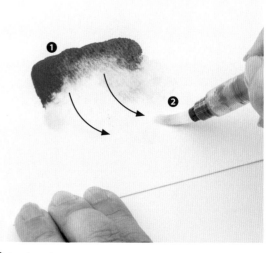

❶ Apply color using a brush that has been dipped in paint. ❷ Before the paint dries, use a brush that only has water on it to blur the color. It is handy to use two brushes for this purpose.

Taking care of your watercolor brush pen

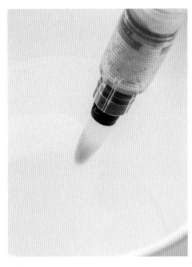

1 **Rinse the tip.**
Rinse the tip in clean water and gently swirl it to remove the paint.

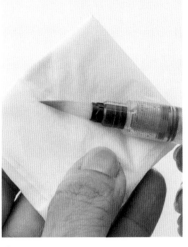

2 **Remove the moisture.**
Gently wipe off the excess water with a tissue.

3 **Neaten the tip.**
Gently neaten the tip using the edge of a tissue so that it keeps its shape.

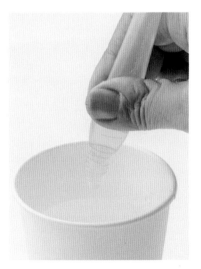

4 **Discard the water.**
After use, empty the water from the barrel.

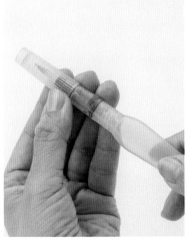

5 **Close the cap.**
Close the cap tightly, taking care not to trap the bristles.

The advantage of a watercolor brush pen is that even if you don't have a brush cup, like when sketching outdoors, you can still paint with different colors.

The Basics of Transparent Watercolor Sketching

Make sure to carefully confirm the principle key points so that you can express what you want when adding color.

1 Erase excess lines before adding color

Once pencil lines have been painted over, they cannot be cleanly erased. Remove any unnecessary lines before starting to add color.

If the pencil lines are dark and clearly visible, before adding color use a kneaded eraser to make the lines fainter, being careful not to damage the paper.

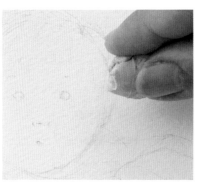

Knead the kneaded eraser well before using it to press on the paper, gently erasing the lines.

If you leave the dark lines in place, they will clearly show through even after adding color.

2 Start by coloring the shadow

Adding the shadows first creates a three-dimensional effect, making it easier to depict the shape and to add color.

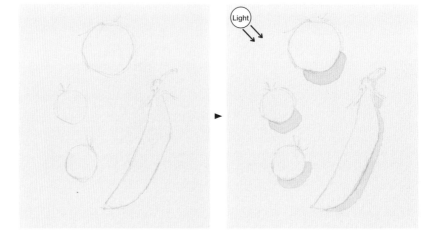

It is easier to identify the shadows if you are aware of the direction of the light.

3 Leave white areas uncolored and paint in order from light to dark

With transparent watercolor paints, colors that have been applied cannot be completely removed. This means areas that you want to be white should be left uncolored to make best use of the whiteness of the paper.

Paint the colors in order from light to dark to create a beautiful finish.

The white flowers are enhanced by painting the surrounding foliage darker.

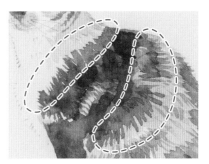

Layering a dark color on a light color creates a beautiful expression for fur too.

4 Wait for colors to dry when you want to avoid bleeding

If you do not want the colors to bleed, for example, between a building and the sky or between the leaves and petals, always check that the colors you already added are dry first.

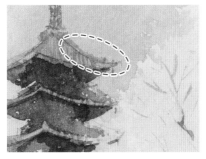

Be aware of whether the previous color has already dried.

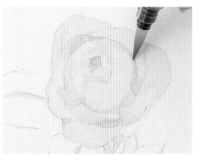

Even when using the same color, make sure it is dry first before layering. In that way you can express realistic flower petals.

5 Add more color to wet paper to create bleeding

For sunsets and other situations where you wish to create a gradation of two or more colors, add the next color before the first one has dried.

So that you are not compelled to rush, prepare all the colors you want to use in your palette beforehand.

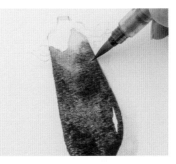

If you layer another color before the one underneath is dry, they will bleed and blend together.

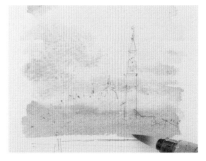

When you are layering a number of different colors at the same time, prepare all the ones you are going to use in your palette beforehand.

Layering the Colors

The attractive thing about transparent watercolors is that the first color applied is slightly see-through. Let us create a check pattern to practice painting lines of different thicknesses and learn to sense the changes in color caused by overlapping them.

Try experimenting with various color and line combinations!

Let one color dry before adding another

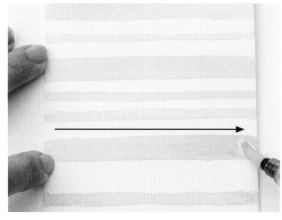

1 Paint a mix of thick and thin horizontal lines in yellow.

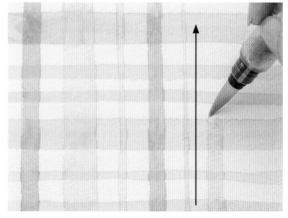

2 Once dry, paint a mix of thick and thin vertical lines in pink.

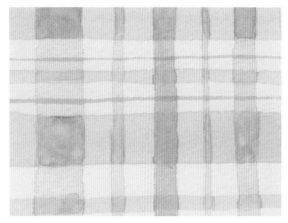

3 If the color where the lines intersect is too light, it is fine to layer the same color again in that area.

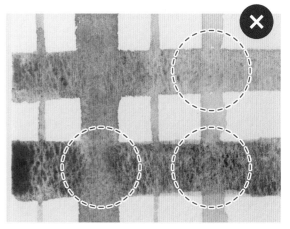

4 If you add more color before the color underneath is dry, it may create bleeding or the color may be lost.

Gradations

Gradation is a technique that is made possible by the characteristics of transparent watercolors. Here, we will practice a monochromatic gradation using different concentrations of paint and water, and a hue gradation with a combination of different colors.

Too much? Or too little? Let's get a feel for how much water is needed!

Create blurring by using water

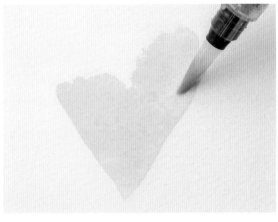

1 Paint the lower half of a heart with yellow.

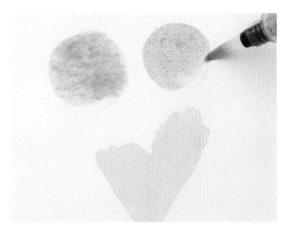

2 Clean the paint off the brush and add a green and a blue circle above.

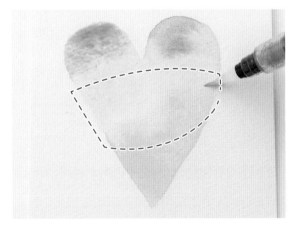

3 Clean the paint off the brush and use only water to bring the three colors together in the center.

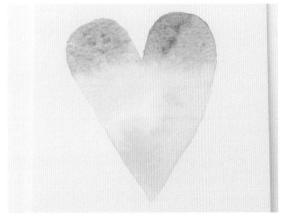

4 Let the water spread the colors rather than trying to combine them too much with the brush.

Color Basics

Depending on how they are combined, colors can be made brighter or duller. Here, I will explain a little about what is good to know about these colors.

Paint colors and color compatibility

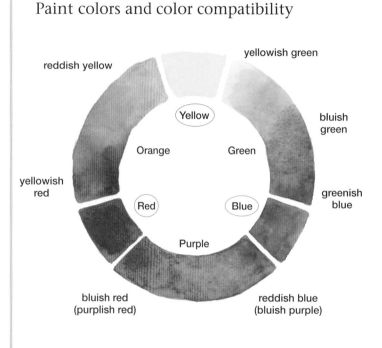

Almost all colors can be created through combinations, but the three primary colors—red, blue and yellow—along with bright pink cannot be made that way, so those paints are necessary.

Colors also have compatibility. The chart on the left is a circle made using the three primary colors. Adjacent colors (yellow and blue, blue and red, red and yellow) are compatible, and when combined create lovely colors. When expressing gradations that use two or more colors, if you are aware of those colors' compatibility, the result will be beautiful.

Complementary colors

If you look at the chart above, you will see purple is opposite the yellow and green is opposite the red. Colors placed like this are called complementary colors, and if you mix them they will become muddy. When you want to apply a complementary color, thoroughly wash the brush first, and then add it after the first color has dried.

As long as you do not mix them, colors on the opposite sides of the color wheel complement each other, so if you can use them skillfully your picture will be impressive.

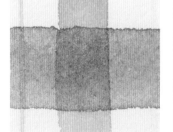

Layering orange, the opposite of blue, will create a muddy color.

Although red and green are complementary colors, if you place them next to each other they both stand out.

CHAPTER 2
Try Painting Familiar Subjects

If you start by painting something that is already on hand, you can get to work right away with a convenient subject. Let's practice.

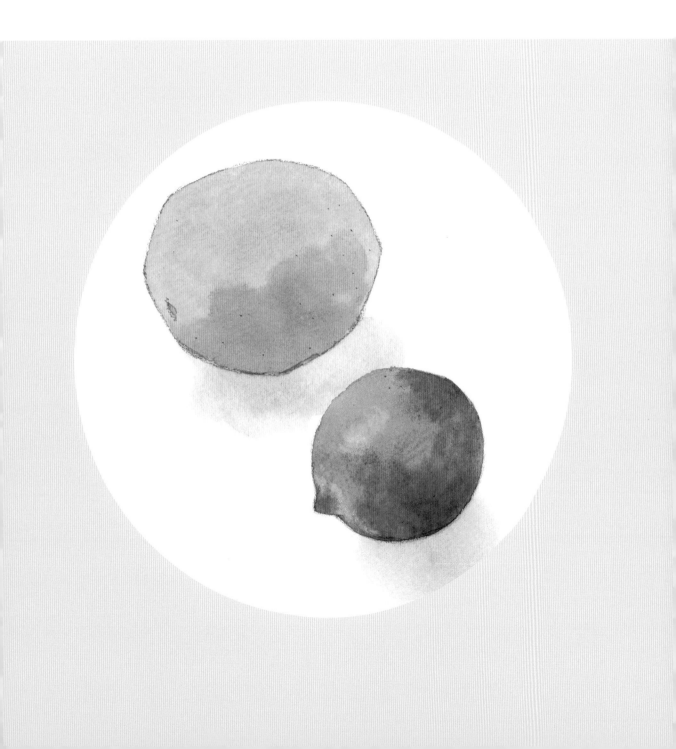

Painting Fruit

An Orange and a Lime

Solid single-color spheroids are a perfect way for beginners to practice watercolor sketching. Once you have roughly depicted the shape, just enjoy painting it.

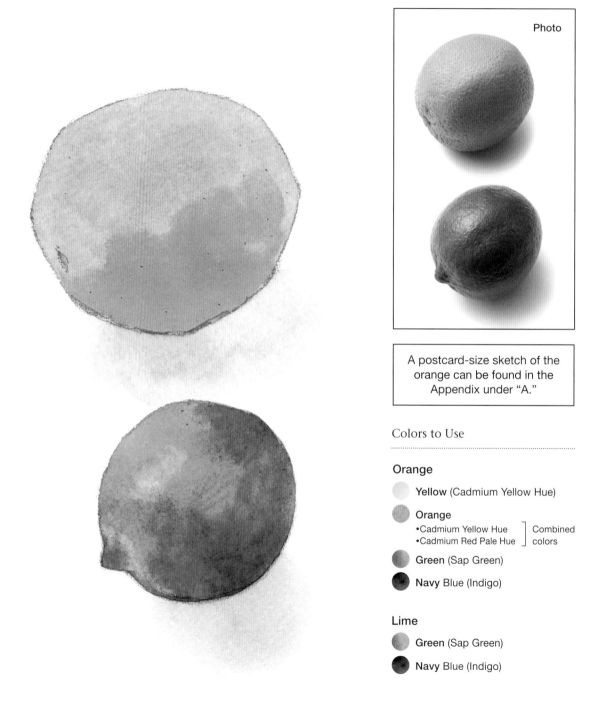

Photo

A postcard-size sketch of the orange can be found in the Appendix under "A."

Colors to Use

Orange

Yellow (Cadmium Yellow Hue)

Orange
•Cadmium Yellow Hue ⎤ Combined
•Cadmium Red Pale Hue ⎦ colors

Green (Sap Green)

Navy Blue (Indigo)

Lime

Green (Sap Green)

Navy Blue (Indigo)

Orange

1 With a pencil, draw faint overlapping short, straight lines to create a rounded outline.

2 Use a brush to color the shadow pale navy blue.

3 Blur the outline of the shadow with water.

4 Once the shadow is dry, color the entire orange using yellow.

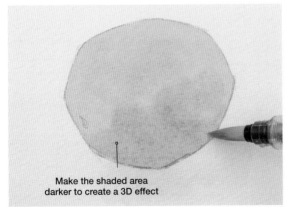

Make the shaded area darker to create a 3D effect

5 Before the yellow dries, paint the bottom part with orange.

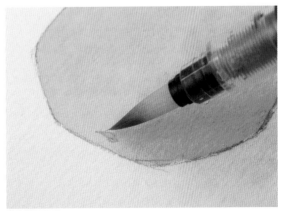

6 Paint the pedicel using light green.

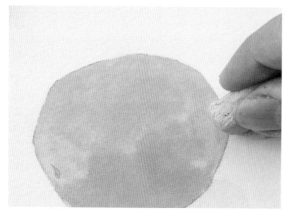

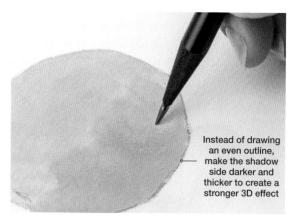

Instead of drawing an even outline, make the shadow side darker and thicker to create a stronger 3D effect

7 Once all the paint is dry, erase any unnecessary pencil lines.

8 Strengthen the outline with a pencil and add dots all over the orange.

Even if the shape is distorted, don't worry, just focus on applying the watercolor paints!

\\ All done! //

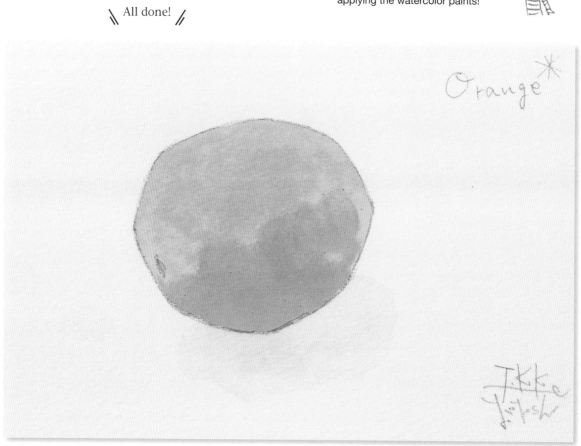

Orange

Lime

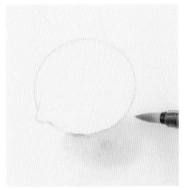

1 Paint the shadow using pale navy blue and blur the outline with water.

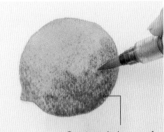

Create a dark area of shading by layering the same color to enhance the 3D effect

2 When the paint in step 1 has dried, paint the whole lime with green, and then layer the bottom part using the same color.

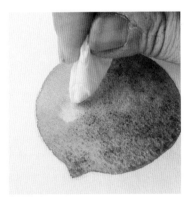

3 While the paint is still not fully dry, blot it with a tissue to create a highlight. Once all the paint is dry, erase any unnecessary lines.

Point

Think about the direction of the light

When light hits an object, the side that the light doesn't reach looks darker. You can create a three-dimensional effect when painting your picture by making the side hit by light a lighter (brighter) color and the other side a deeper (darker) color. Be aware of and carefully observe the direction and shape of the light and the shadow for the object you want to depict.

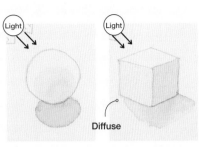

Diffuse

A Sphere's Shadow
Areas that are far from the source of light will be a darker gradation. The shadow on the ground will be round in shape.

A Cube's Shadow
Each side will have a different light density. The shadow on the ground will stretch straight along the cube with a diffuse edge.

Pay attention to the parts in light and those in shadow to create a work that is three-dimensional

\\ All done! //

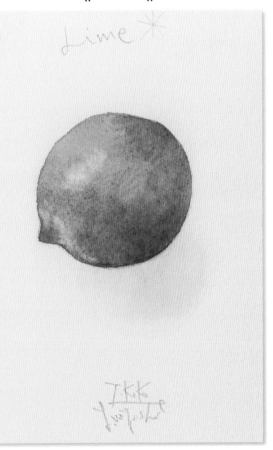

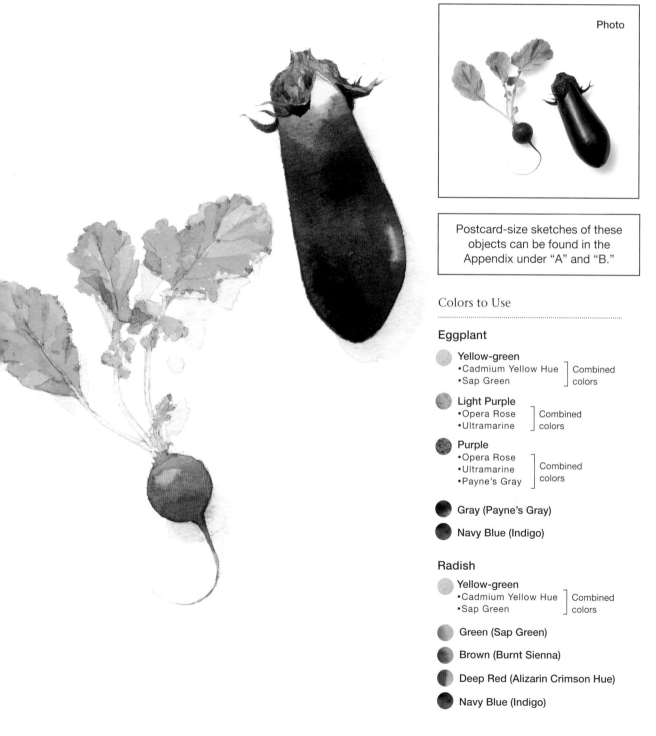

LESSON **2**

Painting Vegetables 1

An Eggplant and a Radish

Let's go a small extra step and paint while paying attention to the shading. By using the whole surface of the brush to apply the paint, you can create a work with shading, even with one color.

Photo

Postcard-size sketches of these objects can be found in the Appendix under "A" and "B."

Colors to Use

Eggplant

Yellow-green
•Cadmium Yellow Hue ⎤ Combined
•Sap Green ⎦ colors

Light Purple
•Opera Rose ⎤ Combined
•Ultramarine ⎦ colors

Purple
•Opera Rose ⎤
•Ultramarine ⎥ Combined
•Payne's Gray ⎦ colors

Gray (Payne's Gray)

Navy Blue (Indigo)

Radish

Yellow-green
•Cadmium Yellow Hue ⎤ Combined
•Sap Green ⎦ colors

Green (Sap Green)

Brown (Burnt Sienna)

Deep Red (Alizarin Crimson Hue)

Navy Blue (Indigo)

Eggplant

1
With a pencil, roughly determine the length and width of the eggplant, along with the position of the stem, and join them together with lines.

2
Color the shadow with pale navy blue.

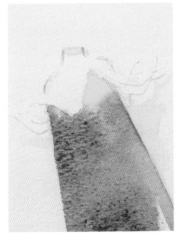

3
Color the area of body close to the stem using yellow-green. Before that yellow-green dries, add light purple.

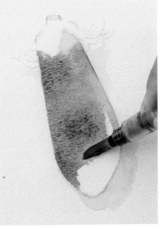

4
Color the whole body light purple, leaving the whitish highlight uncolored.

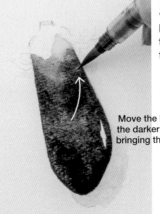

5
Layer purple on top of the color from step 4.

Move the brush toward the darker shaded area, bringing the paint with it

6
Use water to blur the border of the highlight. Keep only a small amount of water on the tip.

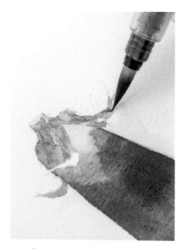

7 Once the paint of the eggplant itself is dry, color the stem with gray and layer it to create shading.

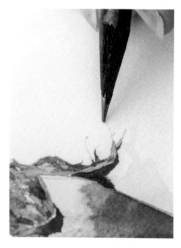

8 Once all the paint is dry, erase any unnecessary lines and with a pencil define the tips of the calyx flaps.

The color of the eggplant is made up of a combination of colors. The hue changes depending on the ratio of paints. What is key is how to bring the paint across with a brush and blurring the borders with water.

\\ All done! //

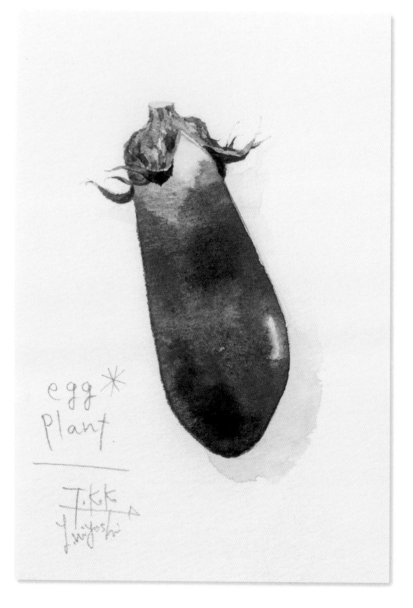

egg* Plant.

Radish

1

With a pencil, draw overlapping short, straight lines to create ① the radish itself, ② the leaf stalks, ③ the leaf midribs and ④ the leaf veins and outlines, in that order.

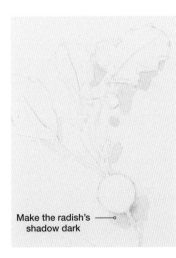

2

Color the shadows of the leaves using pale navy blue.

Make the radish's shadow dark

\ All done! //

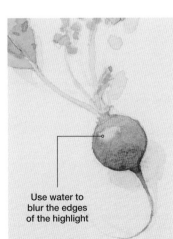

Adding brown makes the leaves look more realistic

3

Color the leaves and stems using yellow-green. Color the leaves by gradually adding green in three stages to darken it and add shading, and then add brown to the tips of the leaves.

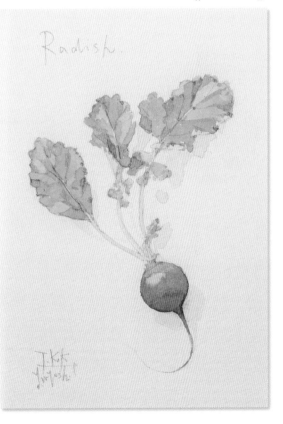

Radish.

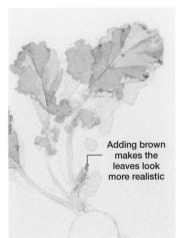

Use water to blur the edges of the highlight

4

Color the radish red, leaving the area where the light hits uncolored, and blur that highlight with water. Once all the paint is dry, erase any unnecessary lines and using a pencil add details to leaf veins and the root ends.

You can paint the radish in the same way as the eggplant. Using some creativity with the color of the leaves lends a heightened level of realism.

Painting Vegetables 2
Cherry Tomatoes and Snap Peas

The key to depicting a number of motifs on a single sheet of paper is to make sure to do things simultaneously. Instead of painting the objects one by one, paint them together, while paying attention to the overall balance.

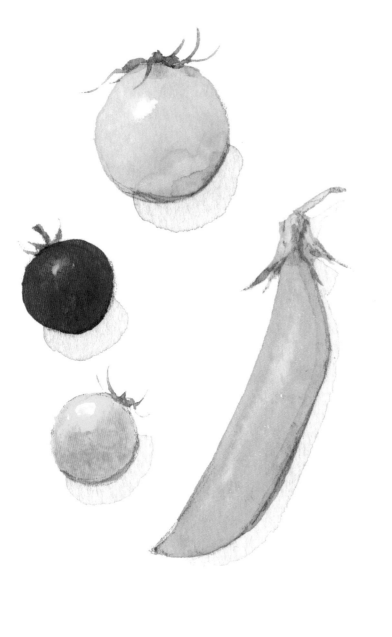

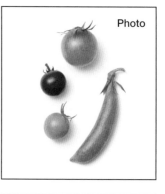

Photo

Postcard-size sketches of these objects can be found in the Appendix under "B."

Colors to Use

Cherry Tomatoes

Yellow (Cadmium Yellow Hue)

Yellow-green
•Cadmium Yellow Hue ⎤ Combined
•Sap Green ⎦ colors

Deep Red (Alizarin Crimson Hue)

Deep Green
•Viridian Hue ⎤ Combined
•Burnt Sienna ⎦ colors

Navy Blue (Indigo)

Snap Peas

Green
•Cadmium Yellow Hue
•Sap Green ⎤ Combined
•Burnt Sienna ⎦ colors

Yellow-green
•Cadmium Yellow Hue ⎤ Combined
•Sap Green ⎦ colors

Navy Blue (Indigo)

1 Determine the overall layout. It's fine to use faint pencil lines to mark the positions.

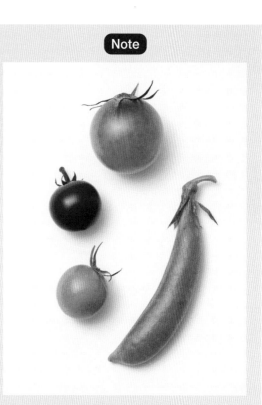

Note

Place the Objects to be Drawn on Paper

If you're not sure about the composition, try placing the actual objects on the paper you are using to help you adjust the balance. It's also easier for beginners to draw objects full size!

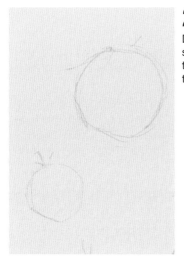

2

Draw overlapping short, straight lines to create the circle of the tomato.

3

For the peapod, mark the length and width and join those points together with lines.

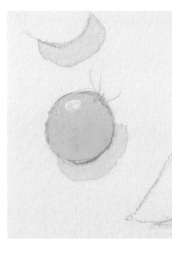

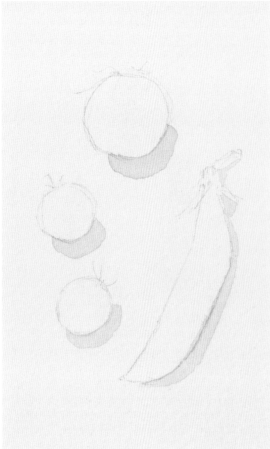

5
Color the whole tomato using yellow, leaving the highlight uncolored, and then create shading by layering the same color on the shaded side.

6
Color the whole area using yellow-green, leaving the highlight uncolored, and then create shading by layering the same color on the shaded side.

4 Use a brush to color the shadow pale navy blue.

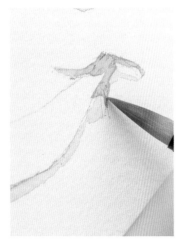

7
Using the yellow-green for the tomato in step 6, color the entire stalk of the peapod.

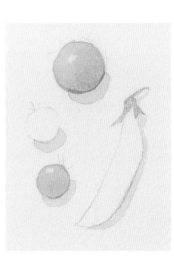

8
Here, all the pale tones of similar colors have been added.

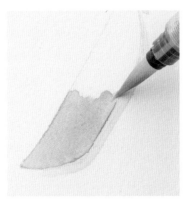

9 Color the whole pod using green, while bringing the paint toward the shaded side.

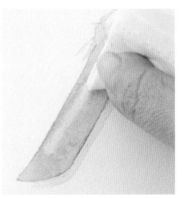

10 Use a dry tissue to gently blot the paint on the highlight.

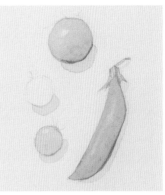

11 Create shading on the tomato and peapod by adding navy blue.

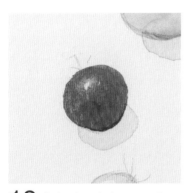

12 Color the whole area using red, leaving the highlight uncolored, and then create shading by layering the same color on the shaded side.

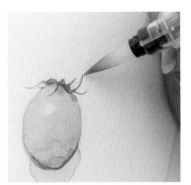

13 Once the whole area is dry, color each tomato calyx using deep green. Erase any unnecessary lines and with a pencil add details to the stalks and other parts.

\\ All done! //

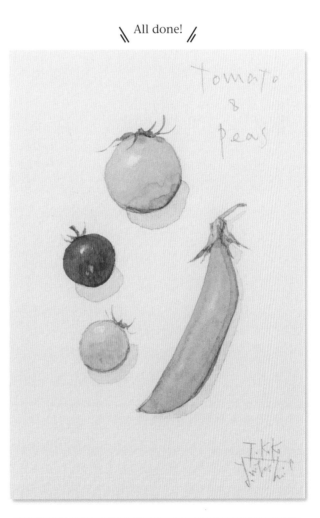

Tomato & peas

Green and red are complementary colors, so be sure to wash the brush well before applying each color so they don't become muddy.

Painting Plants 1
Herbs

Herbs, with their various forms, are great for practicing how to depict shapes and same-color shading. Observe them carefully and get an understanding of their characteristics.

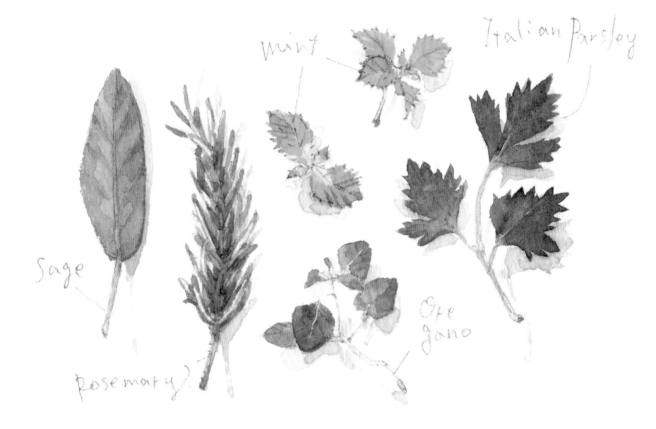

Colors to Use

Yellow-green
- Cadmium Yellow Hue ⎤ Combined
- Sap Green ⎦ colors

Brown (Burnt Sienna)

Green (Sap Green)

Deep Green
- Viridian Hue ⎤ Combined
- Indigo ⎦ colors

Blue-green (Viridian Hue)

Navy Blue (Indigo)

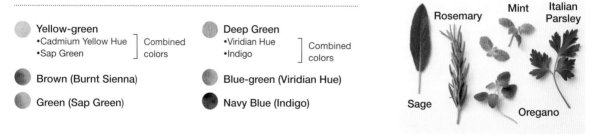

Postcard-size sketches of these objects can be found in the Appendix under "C."

1

Once you have determined the overall composition, use a pencil to draw a rough outline, in order starting from the stalks and midribs, followed by the clearly visible leaf veins, and then the leaves.

2

Use a brush to color the shadow pale navy blue.

Note

The shape of the object also determines the shape of the shadow (narrow leaves cast narrow shadows and broad leaves have broad shadows). If you leave a space between the leaves and the shadows, you can create the impression that they are not pressed flat.

3

Start by using the light colors. Color the midribs and stalks of all the herbs using a yellow-green shade. Before the color dries, add brown to the cut ends at the bottom of the stems and let it bleed.

Note

Identify the Greens!

Even when we use the word "green," there are many different possible shades. Let's learn through coloring various herbs the varied hues of green, like yellowish green, bluish green, bright green and dark green, as well as how to adjust the shading.

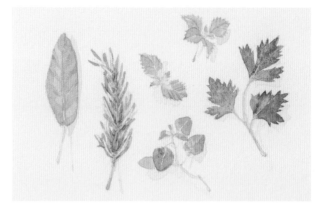

Paint the serrated leaves with a sweeping brush stroke

4 Using green, color one-half of the mint leaves. Layer in certain areas to add shading.

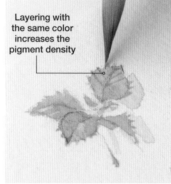

Layering with the same color increases the pigment density

5 Once dry, paint the leaf veins using the same color.

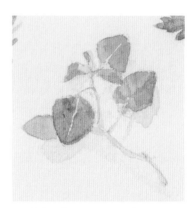

6 Paint the oregano using deep green. Color one side of the leaf and then the other, leaving the midribs in-between, and then layer the color while adding shading.

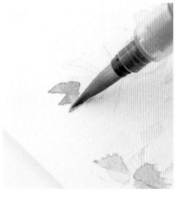

7 Paint the Italian parsley with blue-green. Place the brush to line up with the serrated leaf tips and move the brush toward the center of the leaf.

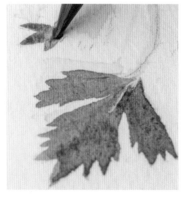

8 Add shading by layering the same color, bringing the paint toward the tips of the leaves.

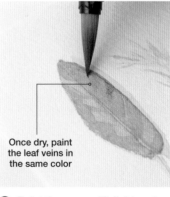

Once dry, paint the leaf veins in the same color

9 Paint the sage with light and dark greens. Paint around the veins, adding light and dark tones to each half of the leaf.

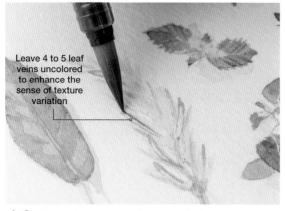

Leave 4 to 5 leaf veins uncolored to enhance the sense of texture variation

10 Color the rosemary leaves with deep green.

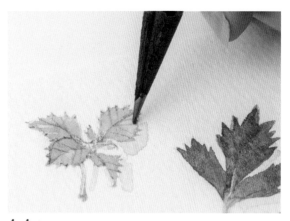

11 Once all the paint is dry, erase any unnecessary lines, and then define the leaf veins and other fine details with a pencil.

Add the names of the herbs and your signature in the margins to complete your artwork! If you color leaves of the same color all at the same time going in order from light to dark, instead of painting each herb individually, your work will go faster.

\\ All done! //

Painting Plants 2
A Sunflower

A sunflower with many petals on a round flower center is suitable for beginners if it is depicted from the front.

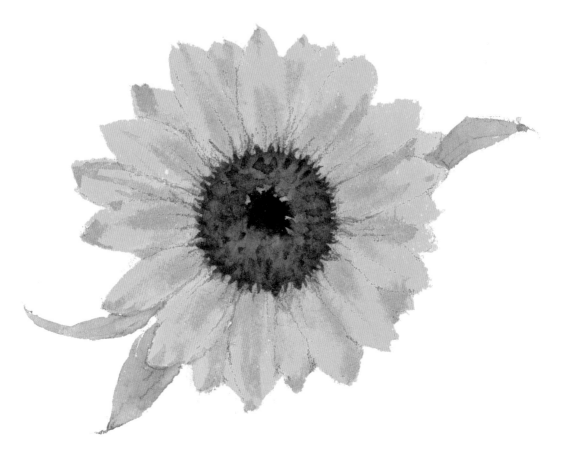

Colors to Use

Flowers

Yellow (Cadmium Yellow Hue)

Bright Yellow
- Cadmium Yellow Hue
- Cadmium Red Pale Hue] Combined colors

Green (Sap Green)

Brown (Burnt Sienna)

Dark Brown
- Burnt Sienna
- Payne's Gray] Combined colors

Leaves

Green (Sap Green)

Ocher (Yellow Ochre)

Shadow

Navy Blue (Indigo)

Photo

A postcard-size sketch of this object can be found in the Appendix under "C."

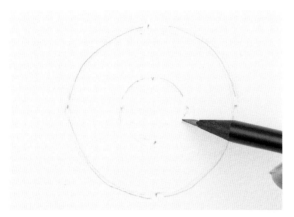

1 With a pencil, roughly draw the circles for the center of the flower and the outer area, and then make marks to denote 4 quadrants.

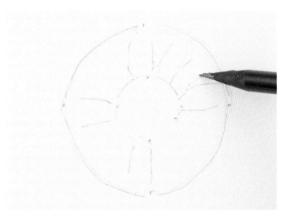

2 Using the marks to guide you, draw 4 petals that don't overlap, and then draw in the remaining petals so as to fill the gaps.

Note

Envision a Clock Face
When a flower has a lot of petals, if you imagine a clock face, it makes it easier to understand the overall shape of that flower.

1. Establish a petal that doesn't overlap at the 12 o'clock position.
2. Informed by step 1, draw lines in the shape of a cross.
3. Establish the petals that are completely visible at the 3, 6 and 9 o'clock positions.
4. Fill in the petals in-between.

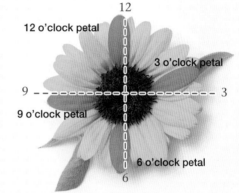

3 Draw the leaves to complete the sketch.

4 Use a brush to color the shaded area with pale navy blue.

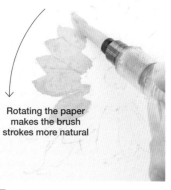

Rotating the paper
makes the brush
strokes more natural

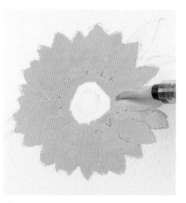

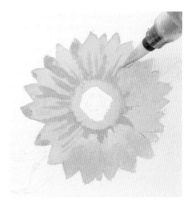

5 Aligning the tip of the brush with the tips of the petals, color each one.

6 Color the whole flower in one session.

7 Using bright yellow, color the center of the flower and tips of the petals where they are shaded and look darker.

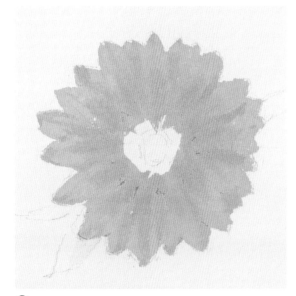

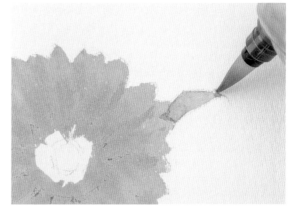

9 Color the leaves using light green. Add a faint touch of ocher to the tips of the leaves.

8 Here, the shading has been added to the petals. By adding yellow shading, the entire sunflower appears more three-dimensional.

10 Color the periphery of the center with light green, leaving the center itself uncolored, and then color accents using brown. The stamens are painted to look like they are overlapping and spraying outward using the tip of the brush.

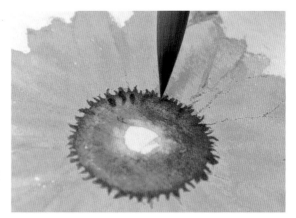

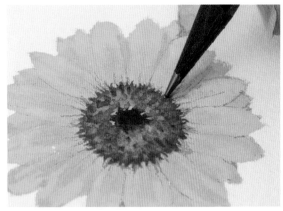

11 Color the center with dark brown, using the tip of the brush to make it look like the color is spraying outward.

Standing the tip upright makes it easier to paint fine lines

12 Once the entire piece is dry, erase any unnecessary lines, and add details to the stamens and petal folds using a pencil.

Making the petals irregular creates a more natural look.

\\ All done! //

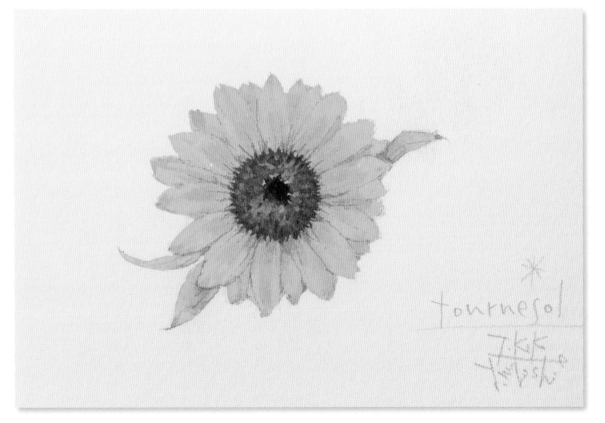

tournesol

Painting Plants 3
A Rose

Depict the overlap of the layered rose petals using shading. Color each half of the leaves divided by the midrib, allowing the first half to dry before painting the second half. Keep the shadows in mind while painting.

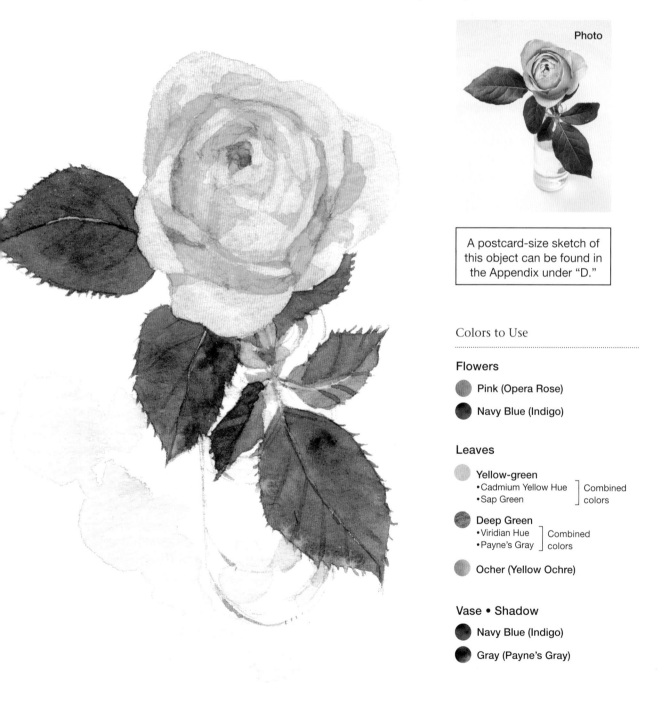

Photo

A postcard-size sketch of this object can be found in the Appendix under "D."

Colors to Use

Flowers

● Pink (Opera Rose)

● Navy Blue (Indigo)

Leaves

● Yellow-green
 •Cadmium Yellow Hue ⎤ Combined
 •Sap Green ⎦ colors

● Deep Green
 •Viridian Hue ⎤ Combined
 •Payne's Gray ⎦ colors

● Ocher (Yellow Ochre)

Vase • Shadow

● Navy Blue (Indigo)

● Gray (Payne's Gray)

1 Sketch the entire shape of the flower.

2 Draw the outer petals and the center of the rose.

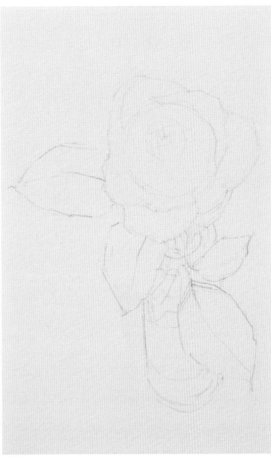

3 Sketch the outlines of the leaves, midribs and vase to complete the sketch.

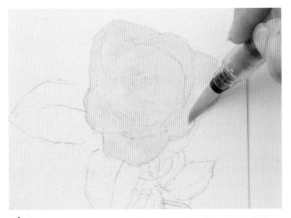

4 Color the entire area of the petals using light pink.

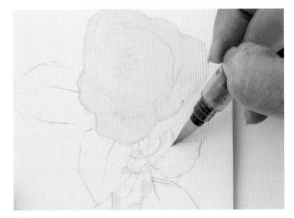

5 Color the parts that will be in shadow, like the mouth and bottom of the vase, and the surface of the water, using pale navy blue.

6 Paint the stalks and midribs of the leaves thickly with yellow-green.

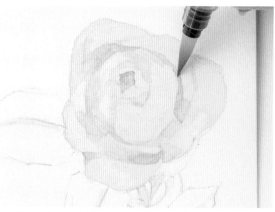

7 Once the paint from step 4 is dry, layer the areas where the petals overlap and create shadows using pink.

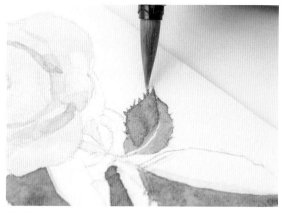

8 Use dark green to paint along one boundary of each midrib, and then color half of each leaf one by one. Then, proceed to color the remaining halves of the leaves once the first halves have dried.

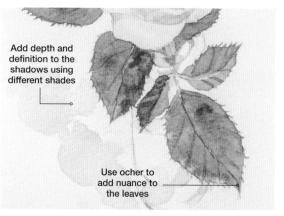

Add depth and definition to the shadows using different shades

Use ocher to add nuance to the leaves

9 Use dark green to paint the leaf veins and tint the tips of the leaves with ocher. Add definition to the shadows and vase using gray and navy blue.

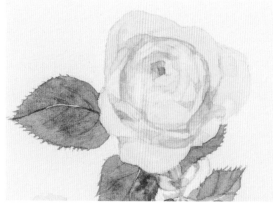

10 Once the paint from step 7 is dry, add a small amount of navy blue to the pink and use that to create shading where the petals overlap.

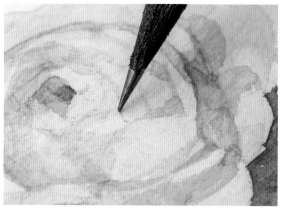

11 Once all the paint is dry, erase any unnecessary lines and add the outlines of the petals using a pencil.

The addition of the vase's shadow makes it more dramatic!

\\ All done! //

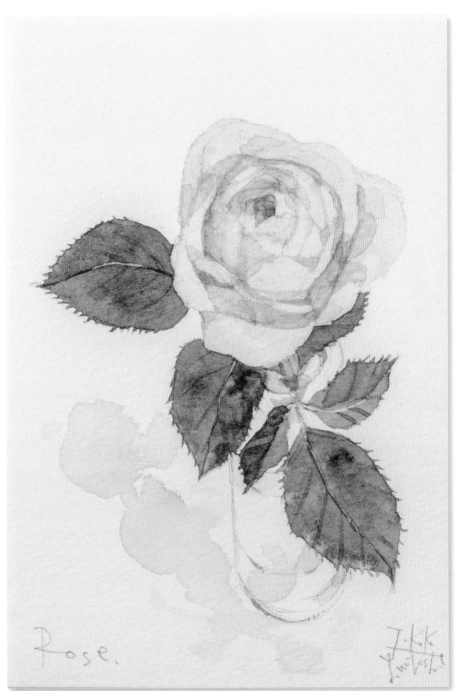

Rose.

Painting Plants 4

A Bouquet

When painting a group of motifs, the key point is deciding which one plays the major role. In the case of a bouquet, decide which flower you want to be the "star" and paint from there.

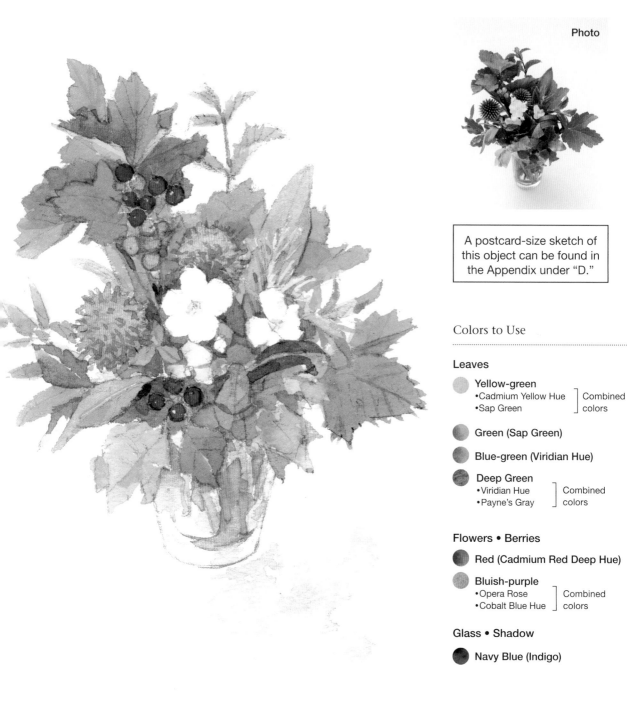

Photo

A postcard-size sketch of this object can be found in the Appendix under "D."

Colors to Use

Leaves

Yellow-green
•Cadmium Yellow Hue ⎫ Combined
•Sap Green ⎭ colors

Green (Sap Green)

Blue-green (Viridian Hue)

Deep Green
•Viridian Hue ⎫ Combined
•Payne's Gray ⎭ colors

Flowers • Berries

Red (Cadmium Red Deep Hue)

Bluish-purple
•Opera Rose ⎫ Combined
•Cobalt Blue Hue ⎭ colors

Glass • Shadow

Navy Blue (Indigo)

1 Outline the entire shape of the bouquet. With a pencil, mark the rough positions as a guide and join them together with lines.

2 Using the central white flower as the main focal point, sketch the positions of the flowers and leaves.

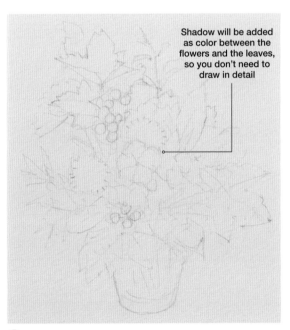

Shadow will be added as color between the flowers and the leaves, so you don't need to draw in detail

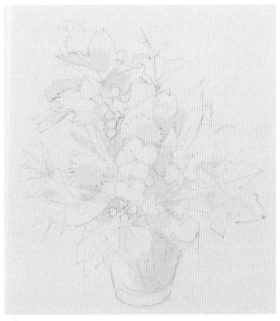

3 The completed sketch.

4 Color the parts in shadow using pale navy blue.

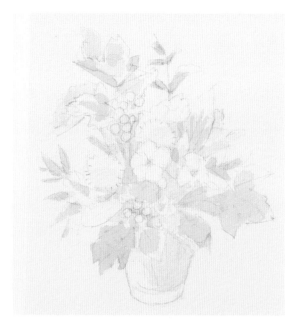

6 Color the flowers with bluish-purple. Once you have colored the whole area to look round, indicate petals by flicking the tip of the brush out to the edges.

5 Start by using the light colors. The whiteness of the paper is used for the white flowers, so leave the petals uncolored and just color the leaves and flower centers with yellow-green. Next, color the berries using light red.

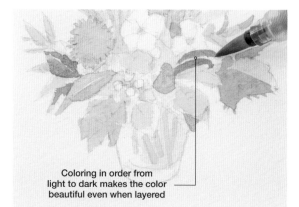

Coloring in order from light to dark makes the color beautiful even when layered

7 Once the paint from step 5 is dry, color the leaves using green. Apply various shades such as dark green and blue-green.

8 Layer the colors more, increasing the density for the leaf tips and veins.

The inside of the vase doesn't need to be depicted clearly

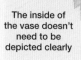

10 For the stems inside the vase, dilute the colors used in step 7 with water.

9 Once the whole area is dry, color the berries with red, leaving the highlights uncolored.

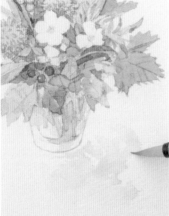

11 Coloring the surrounding leaves darker will make the white flowers stand out even more.

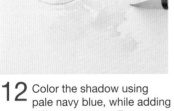

12 Color the shadow using pale navy blue, while adding different shades. Erase any unnecessary pencil lines, and then add the finer details with a pencil.

Instead of using white paint to color white flowers, making use of the whiteness of the paper by leaving them uncolored creates a beautiful white.

\\ All done! //

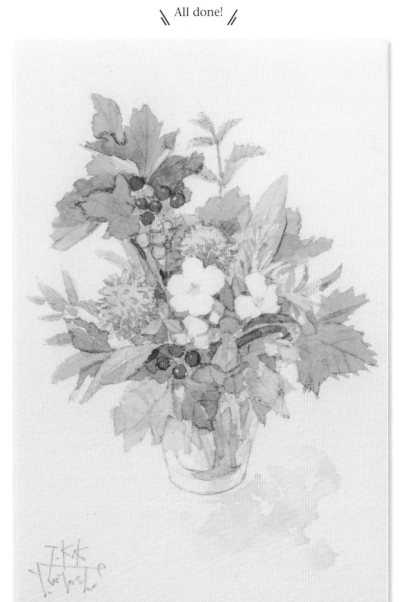

Painting Food
Coffee and Cake

The composition and the colors are important when depicting food. If you can determine an angle that makes the food look delicious, it will become a more attractive work.

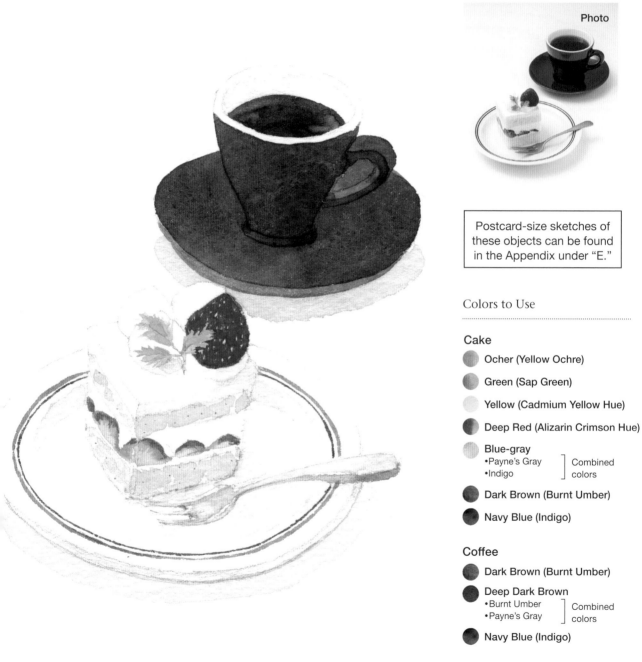

Photo

Postcard-size sketches of these objects can be found in the Appendix under "E."

Colors to Use

Cake

- Ocher (Yellow Ochre)
- Green (Sap Green)
- Yellow (Cadmium Yellow Hue)
- Deep Red (Alizarin Crimson Hue)
- Blue-gray
 - Payne's Gray
 - Indigo } Combined colors
- Dark Brown (Burnt Umber)
- Navy Blue (Indigo)

Coffee

- Dark Brown (Burnt Umber)
- Deep Dark Brown
 - Burnt Umber
 - Payne's Gray } Combined colors
- Navy Blue (Indigo)

Shadow

- Navy Blue (Indigo)

From a high angle, the lip of the cup and plates look oval

1 With a pencil, draw the two plates as ovals, and then add cross-shaped lines in the center to use as guidelines to sketch the cup, cake and fork.

Erase the guidelines before adjusting the shape

2 Neaten up the shapes of the cup, sponge cake, strawberry, plates and fork.

Adding different shades to the shadow's color creates a 3D effect

3 Color the shadow with pale navy blue.

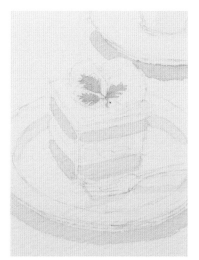

4 Color the sponge cake using light ocher and the mint with green.

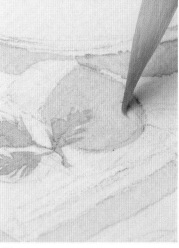

5 Color the strawberry on top with yellow.

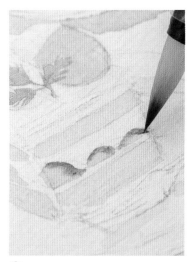

6 Color the cross-sections of the strawberries in the whipped cream with light red, and while the paint is still damp, add red to the outer edges so that the color bleeds.

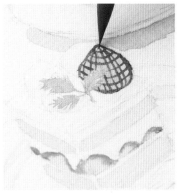

7 Paint gridlines in red on the strawberry.

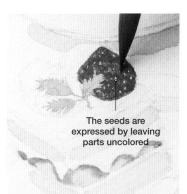

The seeds are expressed by leaving parts uncolored

8 Fill in the grid with color, leaving the seeds, but occasionally filling in entire cells for a natural look.

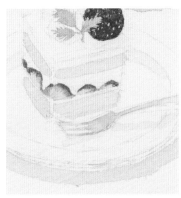

9 Color the fork using blue-gray.

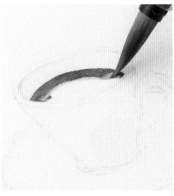

10 Color the far edge of the coffee with dark brown.

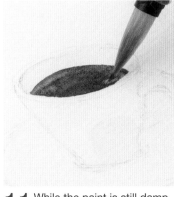

11 While the paint is still damp, color the rest of the area with a deep dark brown.

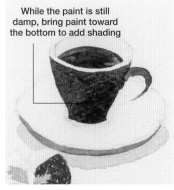

While the paint is still damp, bring paint toward the bottom to add shading

12 Color the rim of the saucer and the cup handle with pale dark brown and color the cup using dark brown.

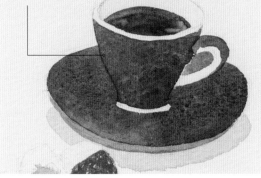

When painting adjacent areas with the same color, allow some drying time between sections so that the edge will appear crisp

13 Color the saucer using dark brown. Color the part of the saucer that can be seen through the handle too.

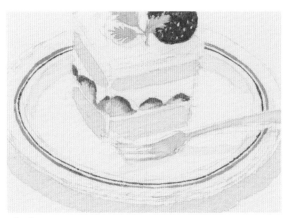

14 Paint the pattern on the cake plate using dark brown and deep dark brown.

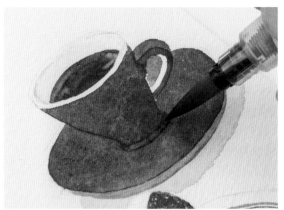

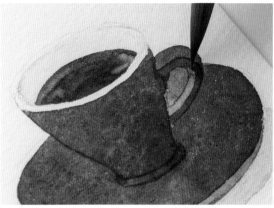

15 Paint the outline of the cup handle edge using deep dark brown, and then use dark brown to color the outside edge. Color the base of the cup left uncolored in step 13 too.

16 Color the inside of the handle using thinned dark brown.

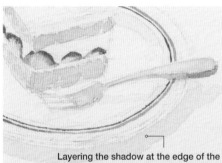

Layering the shadow at the edge of the cake plate gives it more dimension

17 Color the sponge of the cake with ocher, while leaving highlights. Color the mint leaves using green, and the side of the fork with blue-gray.

\\ All done! //

Skillfully combine colors for a polished finish.

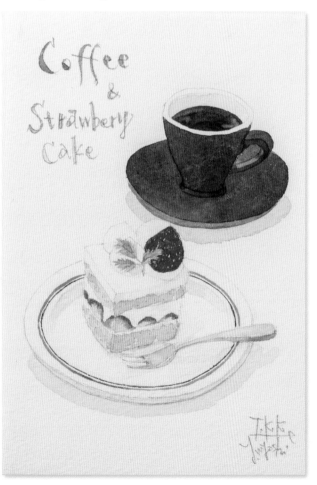

Coffee & Strawbery Cake

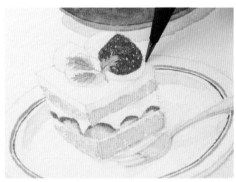

18 Once all the paint is dry, erase any unnecessary lines and add the outlines of the white whipped cream and the specks of the vanilla beans in the sponge cake using a pencil.

Making Delicious-looking Paintings

The key to making sweets look delicious is their colorful appearance. With drinks, you can have more fun by depicting the way the milk blends in, adding the pattern on the cup, and also writing down your thoughts on the taste.

▲ Add milk to coffee by dropping white on to dark brown that is still wet.

▲ Straight tea is expressed by shading brown.

▲ It's fine if the colors on the tableware extend beyond their boundaries. Be careful not to let the colors of the fruit bleed together.

▲ Make a watercolor sketch at a café on holiday. Then, affix a stamp and pop it into the mail. Enjoy the arrangement of the picture and the stamp on the card.

▲ Give lettering a special touch by adding color. Green can be an accent for yellow and brown colors.

▼ Make the table a dark color so that the white cup stands out.

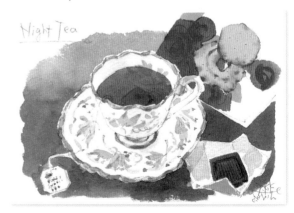

*Pâtisserie Mon Cher | PARFAIT PÊCHES

▲ Add comments about the ingredients and flavors that you would be ignorant of unless you ate them. It's fine if you can't depict them in the picture.

▼ You don't need to show the cake and cup to scale. Paint what you want as large as you want!

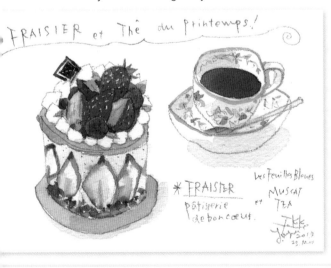

FRAISIER et Thê du printemps!

* FRAISIER
pâtisserie de bon cœur.

Les Feuilles Bleues
MUSCAT et TEA

▼ Paint the strawberry mochi so you can see the filling. If you paint a pattern inside the cup, it gives the green tea transparency.

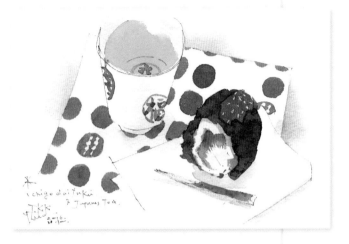

▼ If the dessert is relatively monochromatic and appears a bit drab, add accents like a paper napkin and spoon.

Peach jelly.

LESSON

9

Painting Animals 1

A Cat

Cats have characteristically supple bodies that should be depicted using gentle curves. The key points are realistically painting the fur and successfully arranging the ears, eyes and nose.

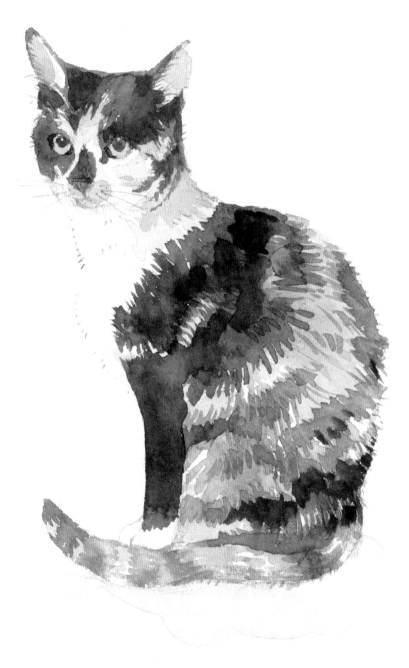

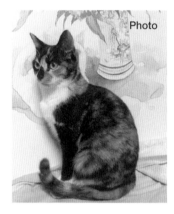

Photo

A postcard-size sketch of this subject can be found in the Appendix under "E."

Colors to Use

Body

- Green (Sap Green)
- Ocher (Yellow Ochre)
- Gray (Payne's Gray)
- Pink (Opera Rose)

Shadow

- Navy Blue (Indigo)

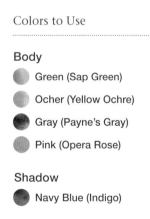

1

Use a pencil to mark reference points around the area, and then join them together with lines to create a rough outline of the face. The position of the tips and bases of the ears are key.

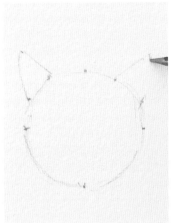

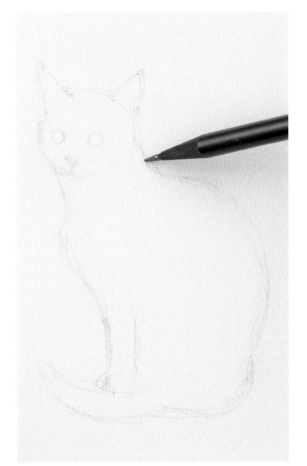

2

Draw a rough outline of the body.

3 For the cat's face, the arrangement of the eyes, nose and mouth are key.

4

Color the shadows on the floor and around the chin with pale navy blue.

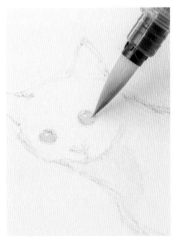

5

Color the eyes using light green. Leave a small uncolored circle in each pupil for the highlights.

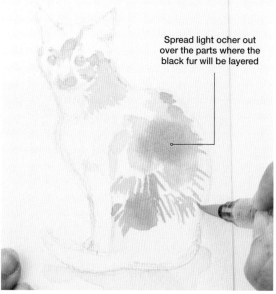

Spread light ocher out over the parts where the black fur will be layered

6 Color the ginger fur using ocher. Create different shades of intensity by overlapping fine strokes while paying attention to how the fur lies.

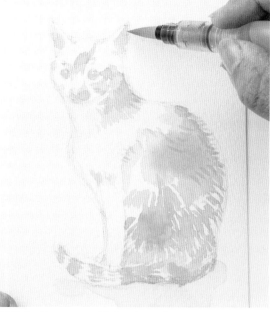

7 Color the ears and tail using ocher.

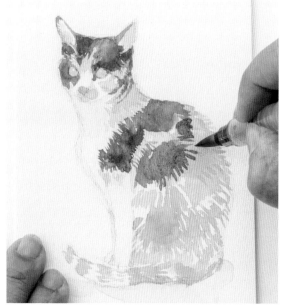

8 Layer light gray, starting from the face, while adding shading.

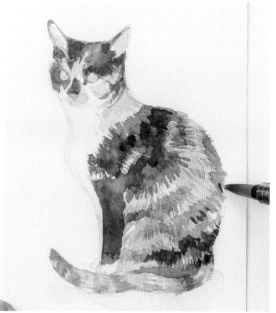

9 Paint using the tip of the brush, representing the way the fur flows.

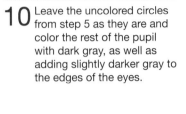

10 Leave the uncolored circles from step 5 as they are and color the rest of the pupil with dark gray, as well as adding slightly darker gray to the edges of the eyes.

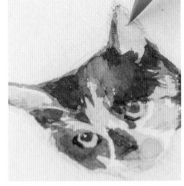

11 Layer the ears with light pink.

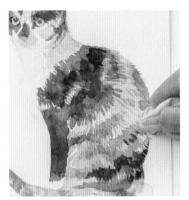

12 Once all the paint is dry, erase any unnecessary lines. Erase the pencil lines on the chest too.

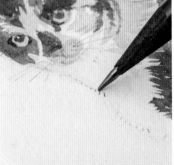

13 With a pencil, add the details of the whiskers and the mouth. For the chest area that was erased in step 12, use short lines to express the fur on the chest.

Use the white paper as a base for the white fur. Use a pencil to mark the outline of the fur so it can be clearly seen.

\\ All done! //

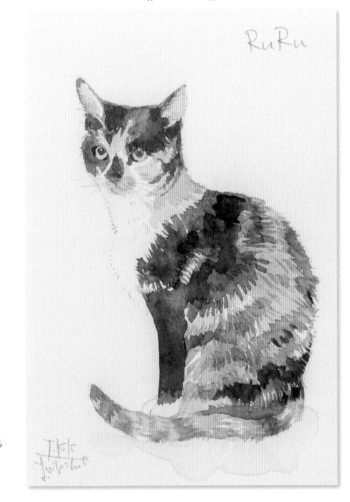

RuRu

Painting Animals 2
A Dog
Dogs are characterized by their sturdy, angular structures. Here, let's work on skillfully depicting a stout body and expressive face.

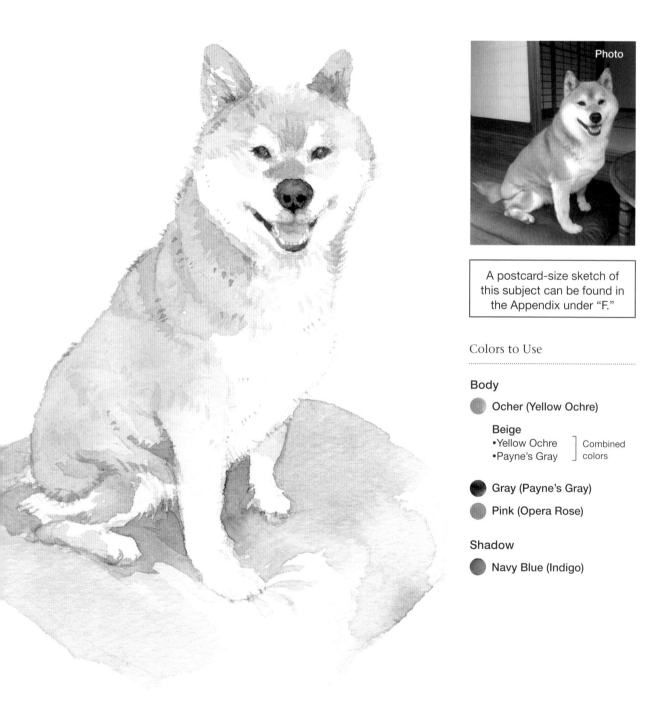

Photo

A postcard-size sketch of this subject can be found in the Appendix under "F."

Colors to Use

Body

● Ocher (Yellow Ochre)

Beige
•Yellow Ochre ⎤ Combined
•Payne's Gray ⎦ colors

● Gray (Payne's Gray)

● Pink (Opera Rose)

Shadow

● Navy Blue (Indigo)

1

With a pencil, draw the overall rough outline. Draw the face while observing the position of each part and draw the body while paying attention to the skeletal structure.

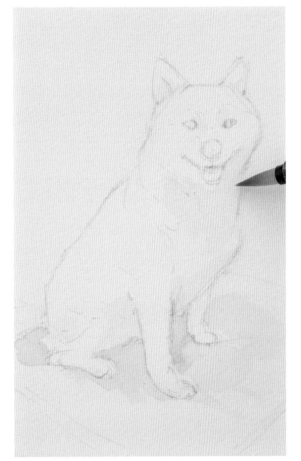

2

Adjust the eyes, nose and mouth. Keep in mind the joints of the legs as you draw them.

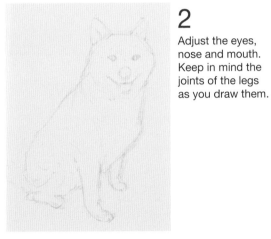

3 Color the shadow with pale navy blue. Paint darker shadows close to the body, and lighter ones around the neck, creating a gradient in the shadows.

4

Color the body using ocher.

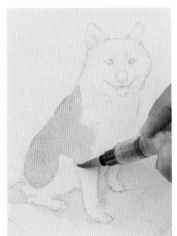

5

Along the boundary with the white fur areas, blur with water to spread the color into a smooth transition.

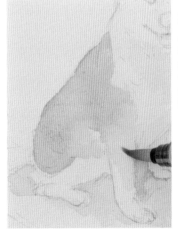

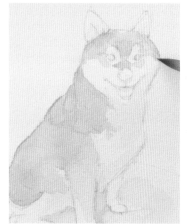

6 Color the face with ocher too and where it borders the white fur blur the color with water, letting it spread. Layer the dark areas of the fur with ocher.

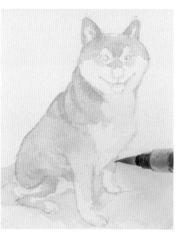

7 Layer with ocher where the fur color looks dark. Paint chest hairs using beige.

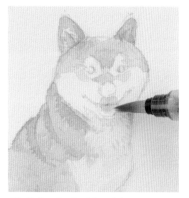

8 Color the inside of the ears and under the nose with light gray. Color the tongue with light pink.

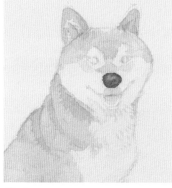

9 Color using dark gray, blurring the tip of the nose with water to create a highlight.

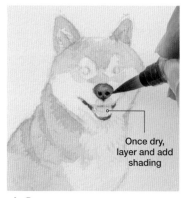

Once dry, layer and add shading

10 Color the mouth with dark gray. Layer the nostrils and under the nose too.

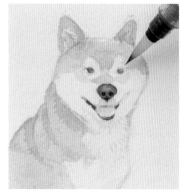

11 Color the pupils with dark gray, leaving small circles for the highlights uncolored.

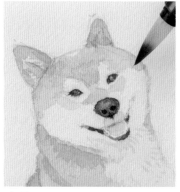

12 Color the inner and outer corners of the eyes, as well as the eyelids with dark gray.

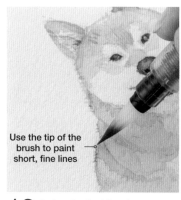

Use the tip of the brush to paint short, fine lines

13 Color the inside of the ears using gray. Define the line of the back using brown.

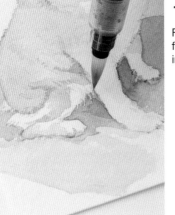

14

For the areas near the white fur, use dark navy blue to add individual lines.

\\ All done! //

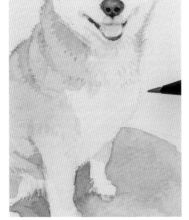

15 Once all the paint is dry, erase all the unnecessary lines. For the white fur, use short lines to express how it lays.

With this brown-colored dog, the shading of the fur has been created through layering and blurring the color with water. The facial expression lies in the arrangement of the ears, eyes, nose and mouth. Be sure to observe carefully.

Try a Variety of Different Animal Poses

Dogs and cats differ when it comes to physique, fur and colors. Short or long hair, standing or floppy ears—identify and paint these different features.

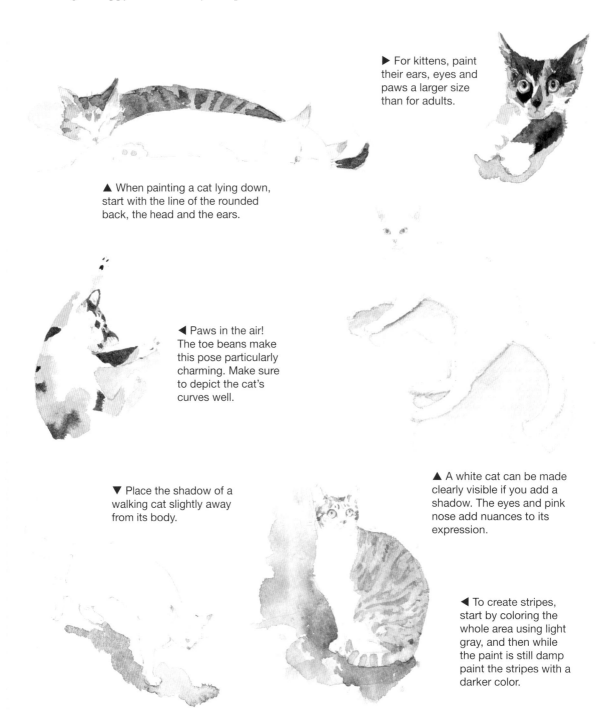

▶ For kittens, paint their ears, eyes and paws a larger size than for adults.

▲ When painting a cat lying down, start with the line of the rounded back, the head and the ears.

◀ Paws in the air! The toe beans make this pose particularly charming. Make sure to depict the cat's curves well.

▼ Place the shadow of a walking cat slightly away from its body.

▲ A white cat can be made clearly visible if you add a shadow. The eyes and pink nose add nuances to its expression.

◀ To create stripes, start by coloring the whole area using light gray, and then while the paint is still damp paint the stripes with a darker color.

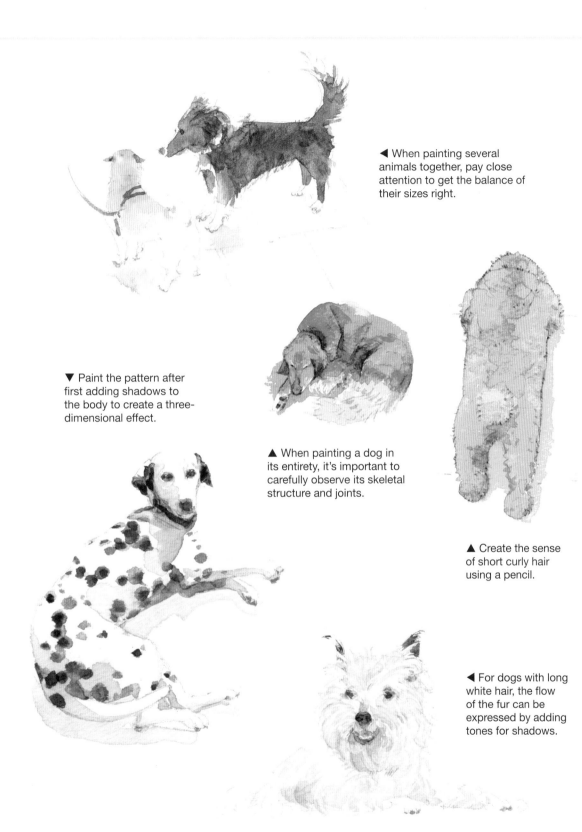

◀ When painting several animals together, pay close attention to get the balance of their sizes right.

▼ Paint the pattern after first adding shadows to the body to create a three-dimensional effect.

▲ When painting a dog in its entirety, it's important to carefully observe its skeletal structure and joints.

▲ Create the sense of short curly hair using a pencil.

◀ For dogs with long white hair, the flow of the fur can be expressed by adding tones for shadows.

Painting People
A Child

For people's faces, determining the position of the eyes or ears first can help you achieve a balanced composition. Even when painting a subject based on a photo, focus on painting the person and not much else to accentuate the expression.

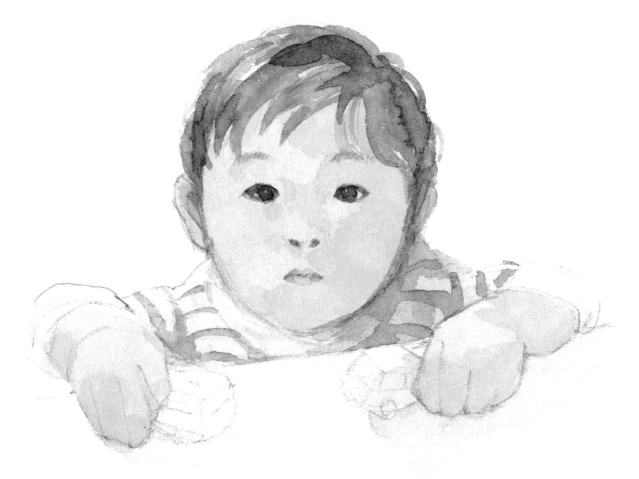

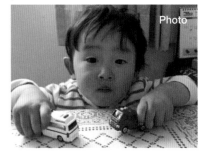
Photo

A postcard-size sketch of this subject can be found in the Appendix under "F."

Colors to Use

Face

 Skin color
•Yellow Ochre
•Opera Rose

Pink (Opera Rose)

Gray (Payne's Gray)

Clothes • Shadow

Navy Blue (Indigo)

1 With a pencil, determine the rough positions of the face, hands and desk.

2 Once you've established the position of the eyes and ears, draw in the nose, mouth and eyebrows.

3 Roughly draw the arms, shoulders, fingers, hair and toys.

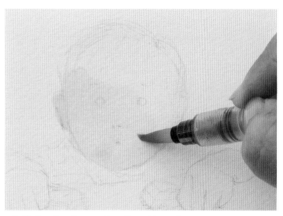

4 Color the face using the skin color.

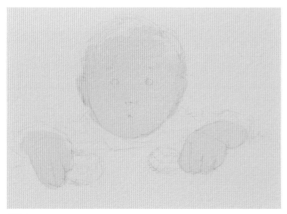

5 Color the arms.

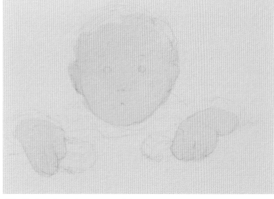

6 Color the cheeks and finger joints with light pink, blending it in with the skin color.

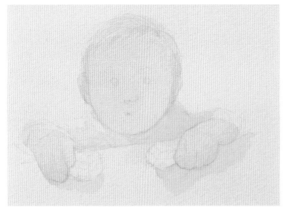

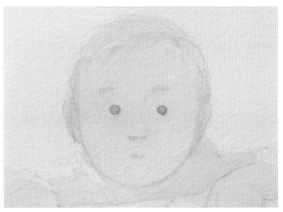

7 Color the hair and clothes using pale navy blue, and then darken the areas in shadow.

8 Color the eyes, nose and eyebrows with light gray.

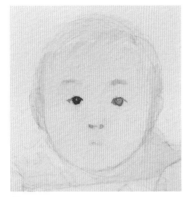

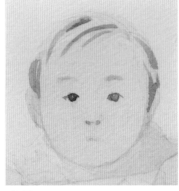

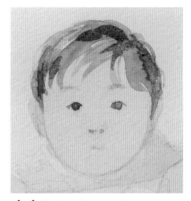

9 Color the pupils with dark gray, leaving small uncolored circles for the highlights, and paint the inner and outer corners of the eyes. Color the eyebrows and nose too.

10 Paint the bangs and sideburns.

11 By layering certain areas and adding darker color, the shading will stand out more.

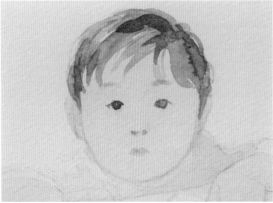

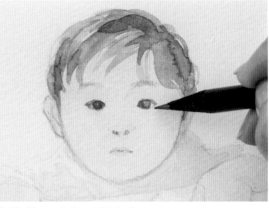

12 Color the lips using light pink.

13 Once all the paint is dry, erase any unnecessary lines, and then add the eyebrows, outer corners of the eyes and other fine details with a pencil.

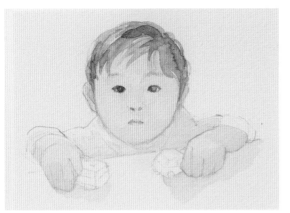

14 Add the outline of the shoulders and arms with a pencil, and then layer the skin color on the face and arms where they are in shadow to create a three-dimensional effect.

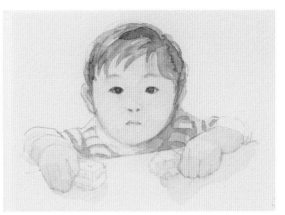

15 Paint the striped pattern of the clothes using navy blue and color the shadows of the toys with pale navy blue.

If you happen to accidentally color in the highlights of the eyes, use a fine white marker pen or correction pen to add them back in again.

 All done!

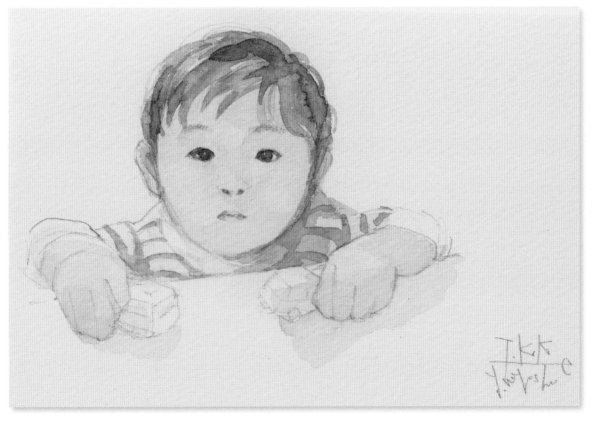

Try Painting the Complete Figure

Be aware of the skeletal structure when painting entire bodies. If you divide the body into sections—the head, torso, arms and legs—and sketch the joints as circles, as shown in the figures on the right, you can more easily understand the poses and the orientations of the parts.

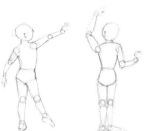

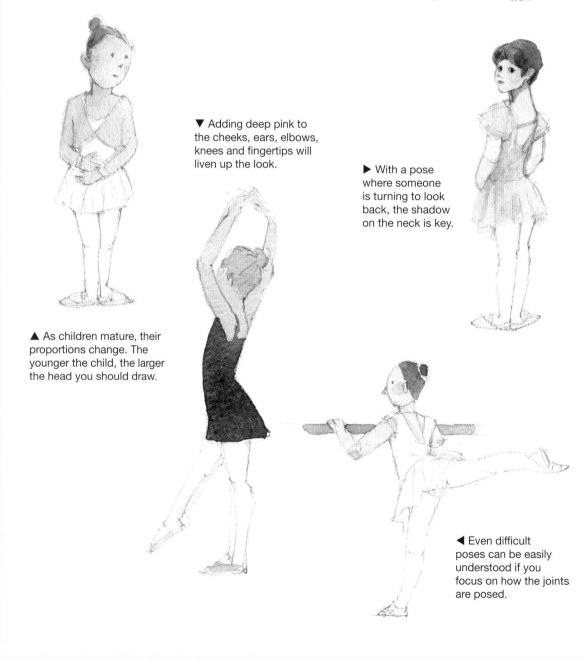

▼ Adding deep pink to the cheeks, ears, elbows, knees and fingertips will liven up the look.

▶ With a pose where someone is turning to look back, the shadow on the neck is key.

▲ As children mature, their proportions change. The younger the child, the larger the head you should draw.

◀ Even difficult poses can be easily understood if you focus on how the joints are posed.

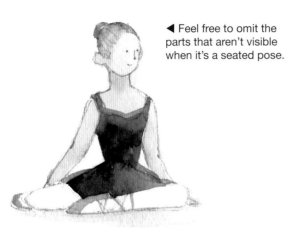

◀ Feel free to omit the parts that aren't visible when it's a seated pose.

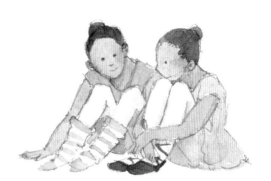

▲ The orientation of the face can be expressed through the positions of the eyes, ears and nose.

▼ With adults, the balance changes even more. Make the limbs long and the head smaller.

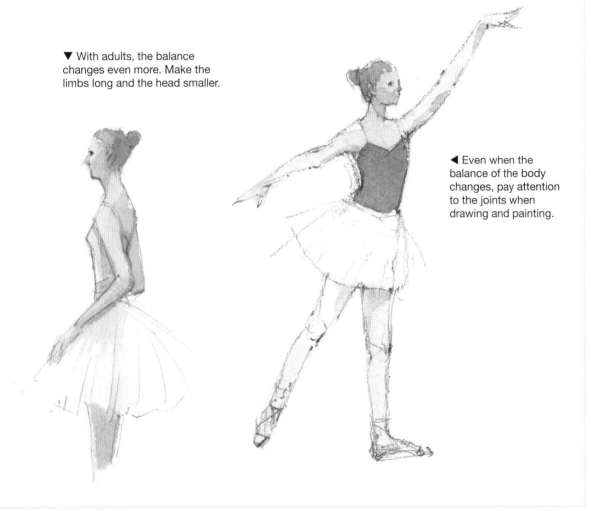

◀ Even when the balance of the body changes, pay attention to the joints when drawing and painting.

Try Painting a Variety of Skies

The sky, made by greatly blurring the whole surface with water, is the most representative motif in watercolor sketching. Let's start by learning how to create a blue sky and then move on to trying various others.

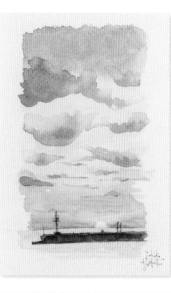

◀ The sun setting out at sea is left uncolored and the clouds reflecting the sunset are added after the sky has been colored using gradation.

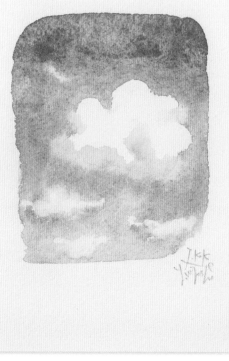

▲ Leave the white clouds uncolored and let light gray bleed in the bottom parts to create a sense of volume.

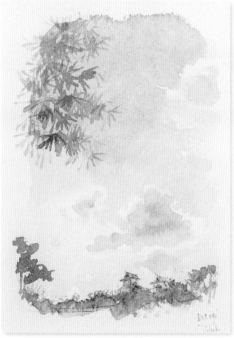

▲ Paint an early morning sky using a gentle light blue. Use light gray for the silhouette to convey the sense that the light is not very strong during this time of day.

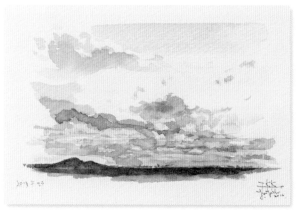

▲ For a sky at twilight, envision adding color to the clouds. Express the areas reflecting the sunset with various hues of red.

CHAPTER 3
Painting Landscapes

Here, we'll try making watercolor sketches of beautiful cityscapes and memorable scenes. Try painting while looking at a photograph.

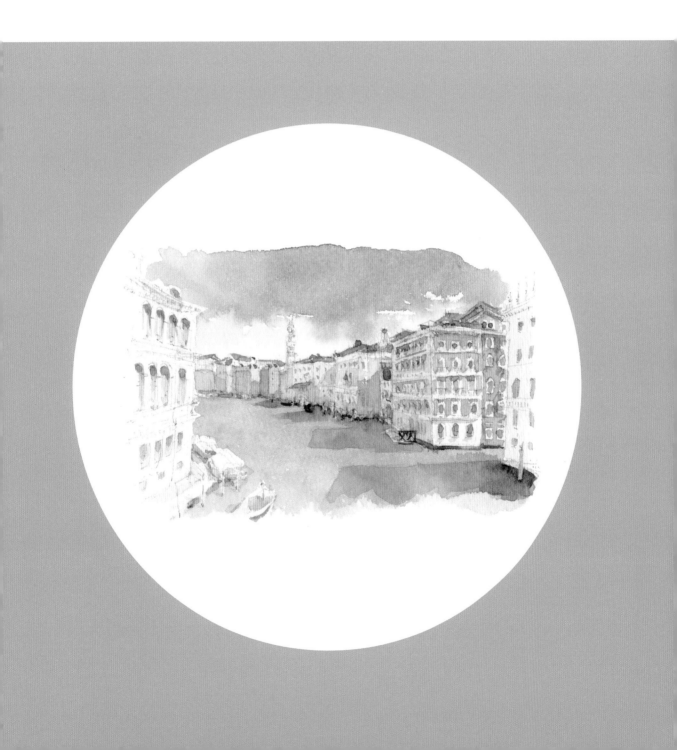

Painting Landscapes 1
Sunset and Sea

As the buildings are in silhouette, this is a landscape that even beginners will find easy to paint. To create the gradation of the sunset, wet the paper and then layer in and blur the colors.

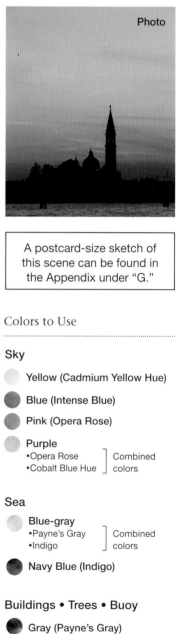

Photo

A postcard-size sketch of this scene can be found in the Appendix under "G."

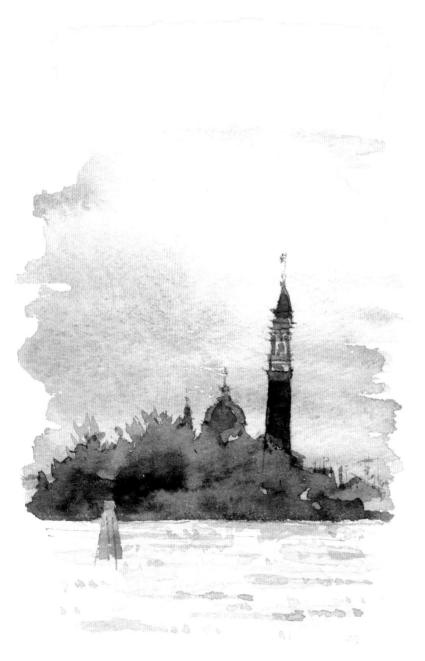

Colors to Use

Sky

Yellow (Cadmium Yellow Hue)

Blue (Intense Blue)

Pink (Opera Rose)

Purple
•Opera Rose ⎤ Combined
•Cobalt Blue Hue ⎦ colors

Sea

Blue-gray
•Payne's Gray ⎤ Combined
•Indigo ⎦ colors

Navy Blue (Indigo)

Buildings • Trees • Buoy

Gray (Payne's Gray)

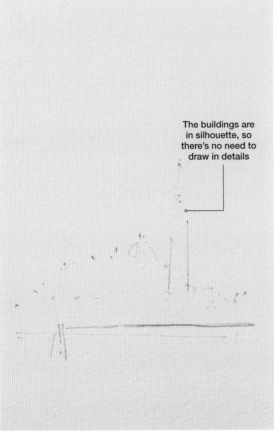

The buildings are in silhouette, so there's no need to draw in details

1 Draw a line between the water and the land with a pencil. Mark points on the horizon for the tower and trees (where they meet the sky) and join them together with lines.

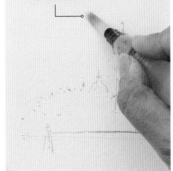

Use enough water to keep the surface wet

2 Wet the whole area of the sky and buildings (up to the border with the sea).

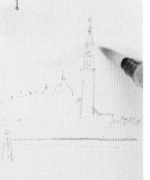

The water on the surface causes the paint to spread quickly

3 Color the whole sky in one pass before the water dries out. Using yellow, broadly color from the top of the sky toward the center.

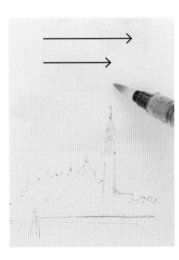

4 Rinse the brush and then add blue to the top area. Move the brush sideways, leaving slight gaps to indicate clouds.

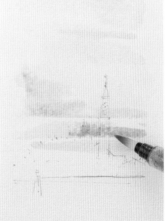

5 Rinse the brush and then quickly add pink to where there are reddish tints in the sky.

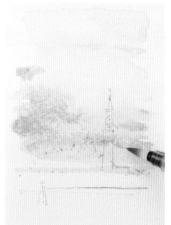

6

For areas that you want to make orange, layer yellow once more over the pink.

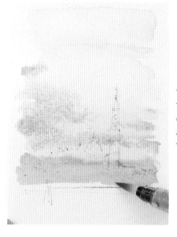

7

Color the area near the horizon using purple.

The sky in steps 3–7 is painted quickly so that the colors blend together. If the paper dries partway through, add just a little bit of water with the brush.

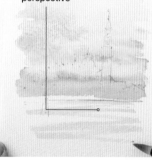

Paint the zigzag lines narrow at the back and broad in the foreground to create a sense of perspective

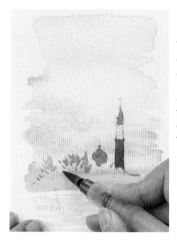

8

Paint the sea with 2–3 separate zigzag strokes using blue-gray paint.

9

To create the impression of waves, paint lines in the zigzag gaps using navy blue. Add a number of dots before the paint dries to represent the waves.

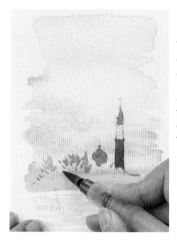

10

When all the paint is dry, paint the tower and roofs that jut out into the sky with dark gray. Layer in the trees from the top down using the tip of the brush.

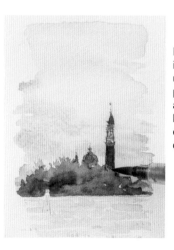

11

Leaving the buoy in the foreground uncolored, layer in the parts between the sea and sky, such as the buildings and trees, etc., with gray and create shading.

12 Color the buoy with light gray.

As the buildings are in silhouette and use a dark color, it's a good idea to paint the sky first, covering the areas where the buildings will overlap.

A pen creates sharper lines than a pencil

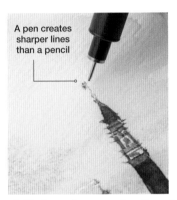

13 Once dry, use a fine-tipped pen to draw the top of the tower and other details.

\\ All done! //

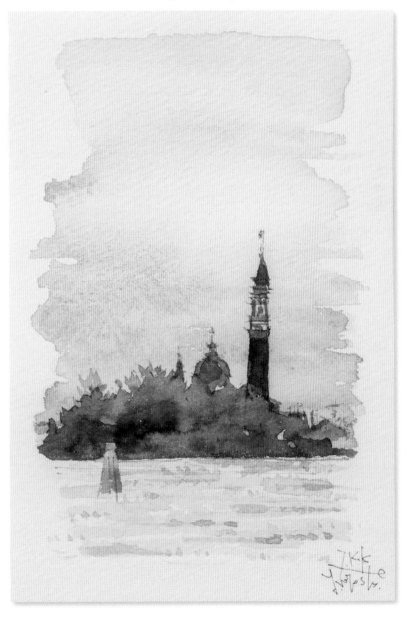

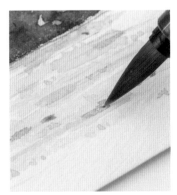

14 Layer the areas where the color seems faint and adjust the overall layout.

Painting Landscapes 2

Buildings by a Canal

To depict the buildings along a small Venetian canal in a two-dimensional composition, focus on capturing the overall texture without getting too caught up in the details of plaster walls, brick facades and tinted windows.
This approach will give your painting a more authentic and atmospheric feel.

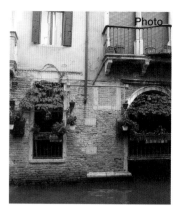
Photo

> A postcard-size sketch of this scene can be found in the Appendix under "G."

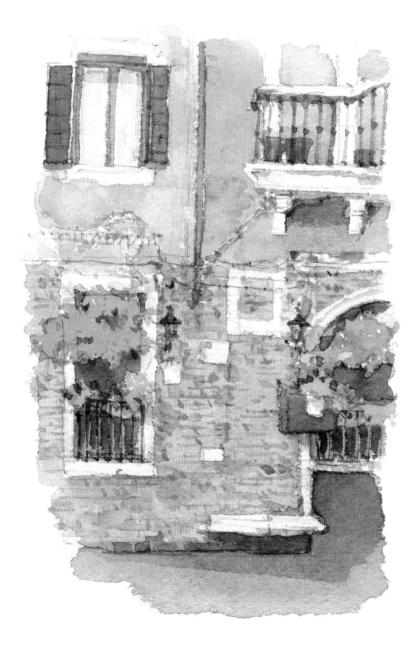

Colors to Use

Wall

○ **Ecru**
 • Yellow Ochre ⎤ Combined
 • Opera Rose ⎦ colors

● **Ocher (Yellow Ochre)**

◑ **Bricks**
 • Burnt Umber ⎤ Combined
 • Cadmium Yellow Hue ⎦ colors

● **Pink (Opera Rose)**

Plants

● **Green (Sap Green)**

● **Blue-green**
 • Viridian Hue ⎤ Combined
 • Indigo ⎦ colors

● **Deep Red (Alizarin Crimson Hue)**

Windows • Shutters • Postbox • Downspout • Lamp • Railings

● **Blue-green**
 • Viridian Hue ⎤ Combined
 • Indigo ⎦ colors

● **Dark Brown**
 • Burnt Umber ⎤ Combined
 • Gray ⎦ colors

● **Gray (Payne's Gray)**

Water Surface • Shadow

● **Navy Blue (Indigo)**

● **Blue-green (Viridian Hue)**

1

With a pencil, draw the boundary between the water and the wall, and use that as a guide to roughly draw the straight-lined elements, such as the window frames and downspout.

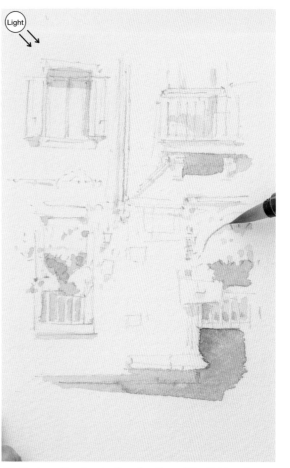

2

Draw in the plants, lamp and plant pots. Mark the top of the arch and draw curved lines to join it to the pillar sections.

3 Paying attention to the direction of the light, color the shadows using pale navy blue. Color the areas in the canal toward the back darker and around the narrow window frames lighter.

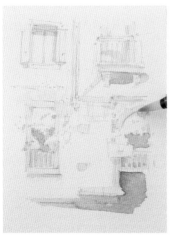

4

Color the whitish window frames and the arch using ecru.

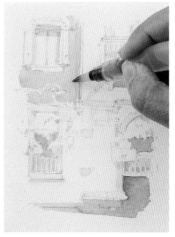

5

Color the top left wall with light ocher. While the paint is still damp, add dark ocher to create shading.

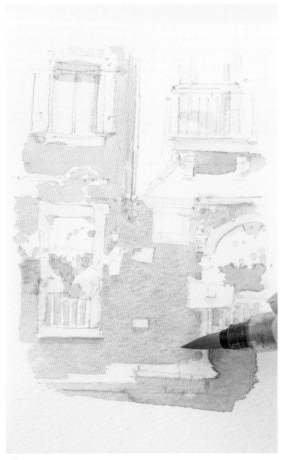

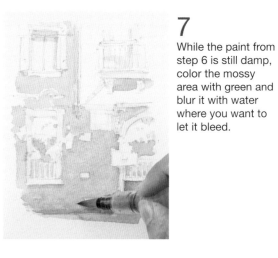

7

While the paint from step 6 is still damp, color the mossy area with green and blur it with water where you want to let it bleed.

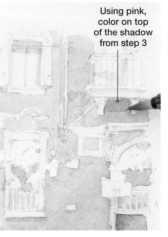

Using pink, color on top of the shadow from step 3

8

Color the top right wall with light pink.

6

Color the bottom half of the wall using the brick color. While the paint is still damp, add pink to create a change in color and give a sense of texture.

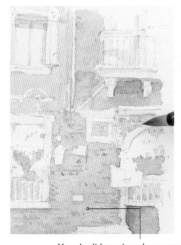

9

Once the paint from step 7 is dry, paint horizontal lines and dots for the bricks using the brick color. Color the top right window using light brick color.

You don't have to color every single brick. Add shading by creating a combination of lines and dots where it looks dark along the boundaries

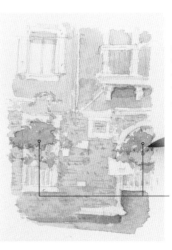

10

Color the plants with green. Layer them partially with blue-green to create shading.

Depict leaves in clusters instead of painting each one separately

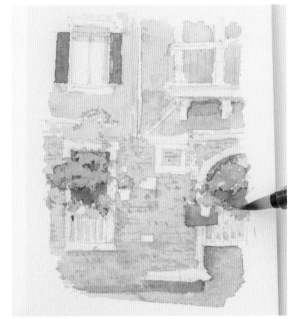

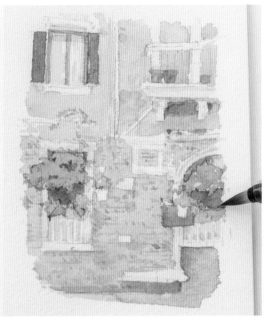

11 Color the shutters and postbox using dark blue-green and the inside part of the windows on the first floor with gray.

12 Color the window frames and plant pots using dark brown.

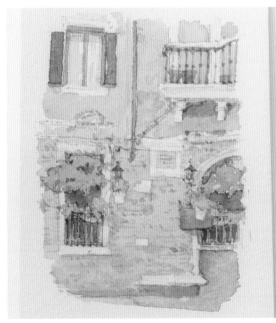

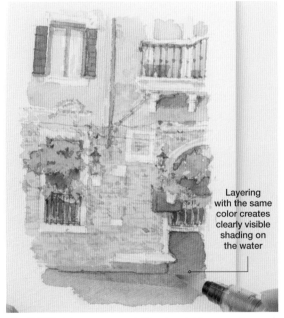

Layering with the same color creates clearly visible shading on the water

13 Color the railings and downspouts with light gray, and then layer with dark gray to add shading and contrast.

14 With blue-green, paint horizontal lines on the shutters of the top left window and color the canal. Layer with the same color in areas that look darker to add shading.

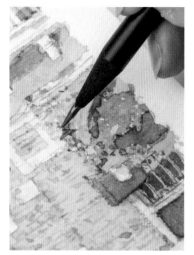

15

Once all the paint is dry, color the flowers using dark red, and the lamp with dark gray. Once dry, use a pencil to add the details.

While this is a composition that focuses on a section of the buildings, avoid filling the entire paper with the image. Instead, leave a margin of about ⅖ in (1 cm) around the work. This creates an impression of wider space and a sense of openness in your artwork.

\\ All done! //

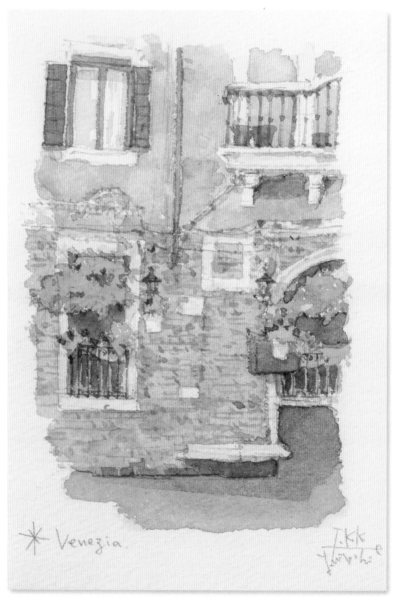

Try Painting a Travel Scene

These are a collection of watercolor sketches from my trip to Paris. Think about representative motifs and compositions that convey the atmosphere of your travel destination.

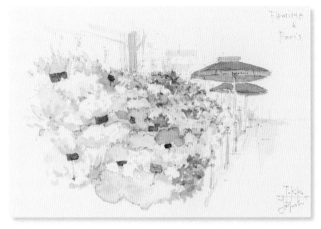

▲ A flower shop in Paris with a colorful array of flowers. You can use colors to convey the atmosphere without needing to paint detailed flowers.

▼ Seats on a restaurant terrace give the impression of strong sunlight when contrasting shadows are added.

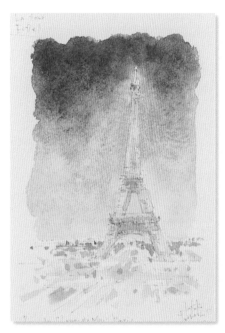

▲ When you think of Paris, you think of the Eiffel Tower. With a well-known building, the painting can of course be of the entire structure, but even just a part of it will create an impression.

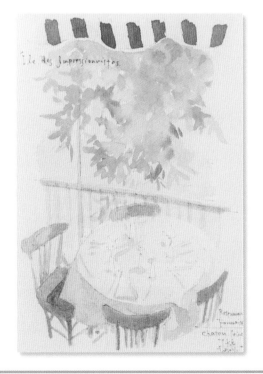

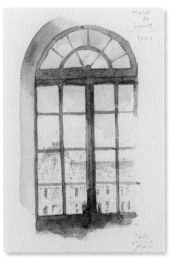

◄ A decorative window at the Louvre. Think of a window as a picture frame.

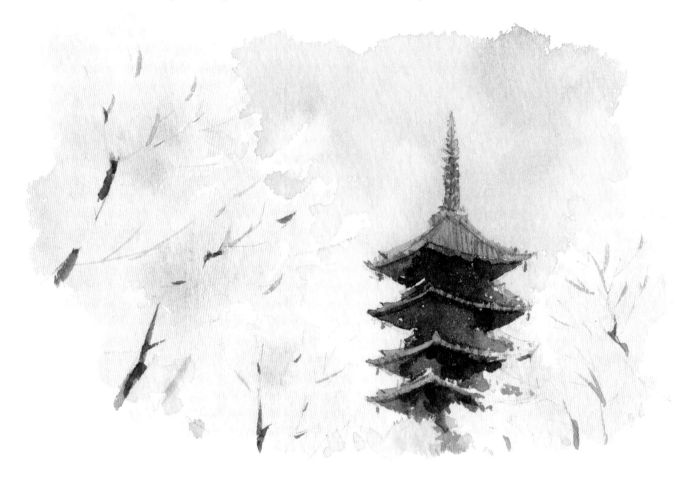

LESSON

14

Painting Landscapes 3
Cherry Blossoms and a Pagoda

The scenery at Tō-ji Temple, Kyoto, in the spring is perfect for
a seasonal picture postcard. The cherry blossoms are created
using blurring and done all at once, not one by one.

Colors to Use

Cherry Blossoms

⬤ Pink (Opera Rose)

⬤ Dark
•Burnt Umber ⎤ Combined
•Gray ⎦ colors

Pagoda

⬤ Gray (Payne's Gray)

⬤ Dark
•Burnt Umber ⎤ Combined
•Gray ⎦ colors

Sky • Foliage

⬤ Blue (Intense Blue)

⬤ Green (Sap Green)

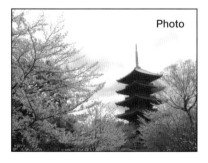

Photo

A postcard-size sketch of this
scene can be found in the
Appendix under "H."

1 With a pencil, roughly mark the position of the cherry tree trunk and branches using faint lines and determine the overall composition.

2 Determine and mark the positions of the top and corners of the pagoda's roof tiers and connect the points with lines to create the overall shape.

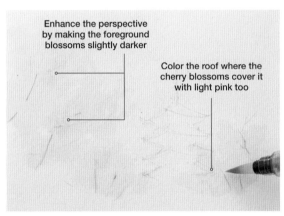

Enhance the perspective by making the foreground blossoms slightly darker

Color the roof where the cherry blossoms cover it with light pink too

3 Color the whole cherry blossom canopy as a unit using light pink, and for the cherry trees in the foreground, layer the color mainly over the branches to create shading.

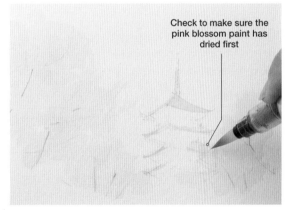

Check to make sure the pink blossom paint has dried first

4 Once the paint from step 3 has dried, color the pagoda roof and the finial on top with light gray.

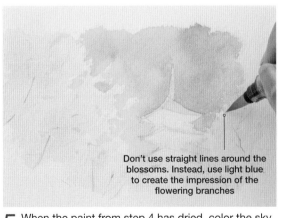

Don't use straight lines around the blossoms. Instead, use light blue to create the impression of the flowering branches

5 When the paint from step 4 has dried, color the sky using light blue, adding shading. Start by coloring the edge of the roof, making sure the color doesn't stray out of the lines.

Color as if laying the paint in place

6 Color the foliage around the base of the blossoms using green and add shading.

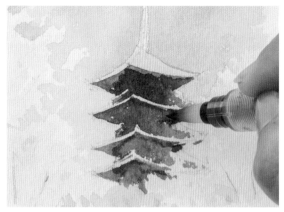

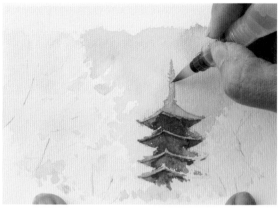

7 Once all the paint is dry, color the eaves and walls with dark brown. Layer the areas that are in shadow to make them darker.

8 Add more gray to the roof and finial.

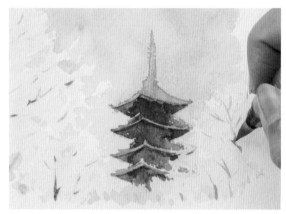

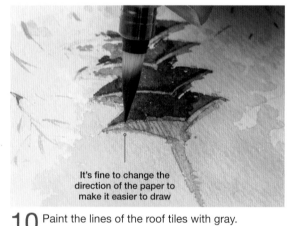

It's fine to change the direction of the paper to make it easier to draw

9 Paint the trunk and branches using dark brown. Make the trunks and branches of the trees in the foreground darker and the ones in the distance lighter.

10 Paint the lines of the roof tiles with gray.

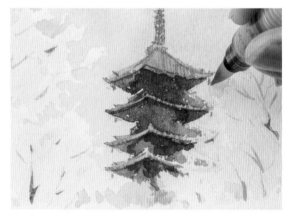

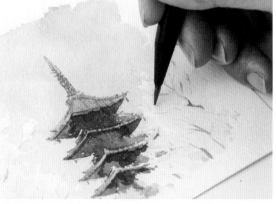

11 Paint the finial and the wind chimes at the tips of the eaves using simple gray lines. This approach will avoid overcomplicating the composition.

12 Once all the paint is dry, use a pencil to add the fine branches and details of the pagoda.

Add another final layer if you feel the pink color of the blossoms is not strong enough.

 All done!

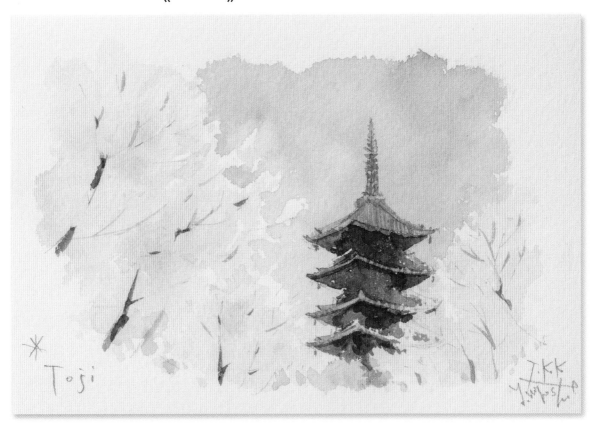

Toji

Note

Use Perspective for Tree-lined Streets

As with cherry blossoms, if you use perspective for tree-lined streets, it makes them easy to paint. Make the trees in the foreground larger and a darker color, while making the ones in the background smaller and lighter in color.

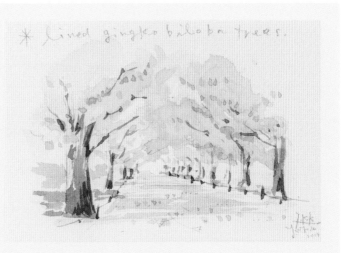

Painting Landscapes 4
A Cityscape with Depth

This is a beautiful cityscape looking along the Grand Canal in Venice. This composition may seem difficult at first glance, but the key to easily creating a dramatic scene is to determine the position of the buildings and simplify the other parts.

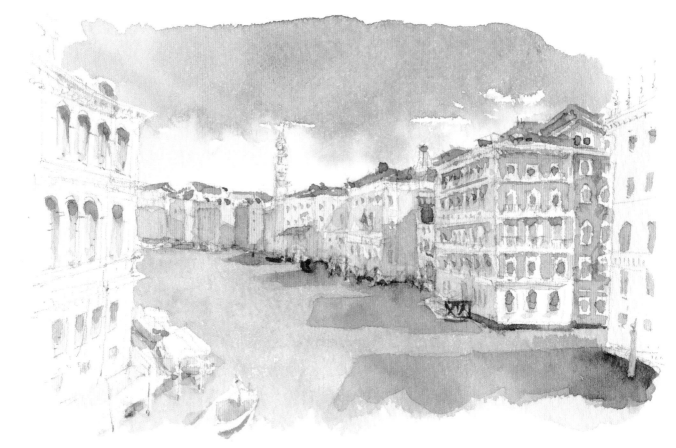

Colors to Use

Sky

● Blue (Intense Blue)

Water Surface • Shadow

● Gray (Payne's Gray)

● Blue-green (Viridian Hue)

● Navy Blue (Indigo)

Buildings

● Ocher (Yellow Ochre)

● Pink (Opera Rose)

● Brown (Burnt Sienna)

● Dark Brown (Burnt Umber)

● Blue-gray
　•Payne's Gray ⎤ Combined
　•Indigo ⎦ colors

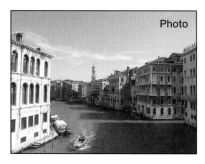

Photo

A postcard-size sketch of this scene can be found in the Appendix under "H."

1 With a pencil, draw the horizon line and the vertical line of the building on the left. Use those as a guide to draw the curved line of the buildings and canal.

2 Draw the vertical line for the building on the right in the foreground.

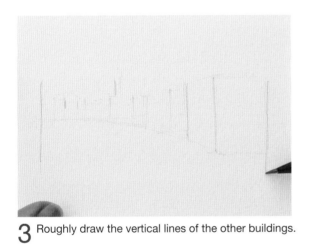

3 Roughly draw the vertical lines of the other buildings.

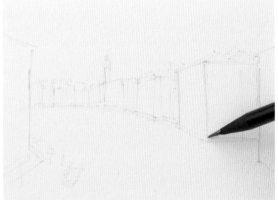

4 Draw the angled lines of the roofs, and adjust each of the shapes.

Note

Be Aware of Perspective

As a straight road or railway line gets closer to the horizon, it appears to gradually become narrower. The technique for showing perspective uses this principle. Setting a vanishing point on the horizon and drawing lines toward it enables you to express distance and depth, as well as create a three-dimensional effect.

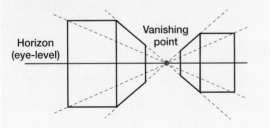

Horizon (eye-level)

Vanishing point

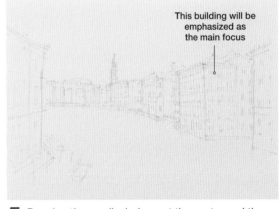

This building will be emphasized as the main focus

5 Drawing the small windows at the center and the two ends of each row first will help create a good guide for filling in the remainder.

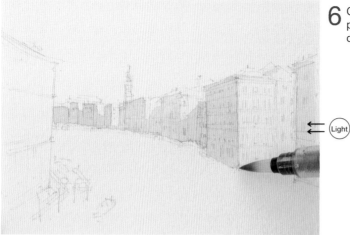

6 Color the shaded sides of the buildings using pale navy blue, while paying attention to the direction of the light.

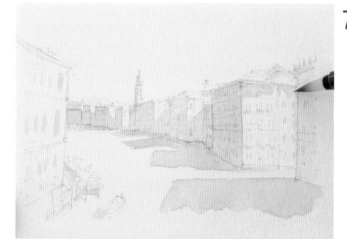

7 Color the shadow of the buildings cast on the water, the moorings, windows and other details using pale navy blue.

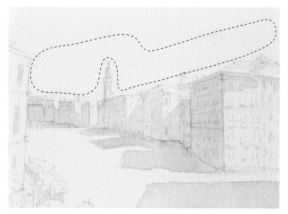

8 Apply water to the area of sky near the roofs.

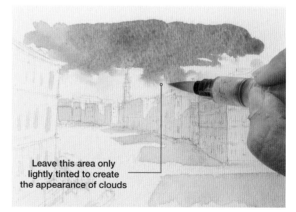

Leave this area only lightly tinted to create the appearance of clouds

9 Starting from the top, color the sky with blue. When you reach the area wet with water from step 8, the color will bleed and get lighter.

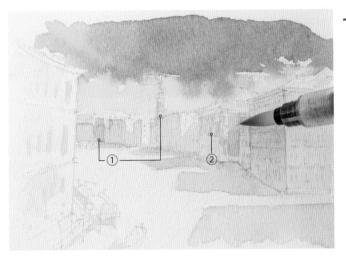

10 Color distant architecture (①) in the background using light ocher, and closer architecture (②) with ocher. Then, layer the paint to increase the color saturation and create shading.

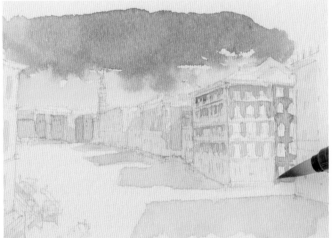

11 Color the building in the background using light pink, and for the wall of the building in the foreground, use brown.

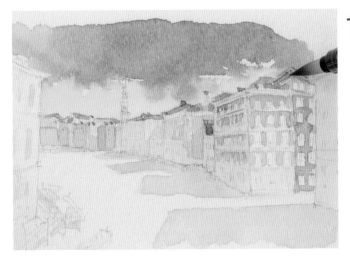

12 Once the sky is dry, color the roofs with diluted dark brown.

13

Color the windows without shutters using gray and leave the white window frames uncolored.

Leave some of the windows uncolored

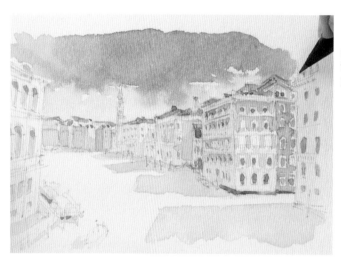

14

Once all the paint is dry, draw in details such as the roofs, boat moorings and balconies with a pencil.

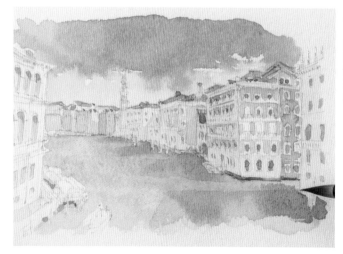

15

Color the whole surface of the water with blue-green. Color some of the windows in the foreground buildings too. Color the areas of the buildings that are in shadow with navy blue to add shading.

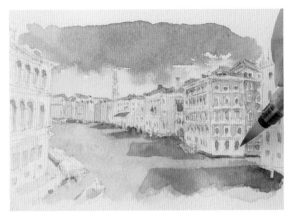

16 Take a look at the whole composition and reinforce areas where you feel the color is not strong enough using the same colors.

17 Color the boats in the foreground with dark blue-green, and for the lowest parts of the buildings, add dark brown. Once all the paint is dry, add the outline of the white building on the right with a pencil to create a sharp look.

Don't add too much detail, as in this way the sense of perspective will be lost. By deciding which details to paint and which to leave out, your work will have a clear focus.

\\ All done! //

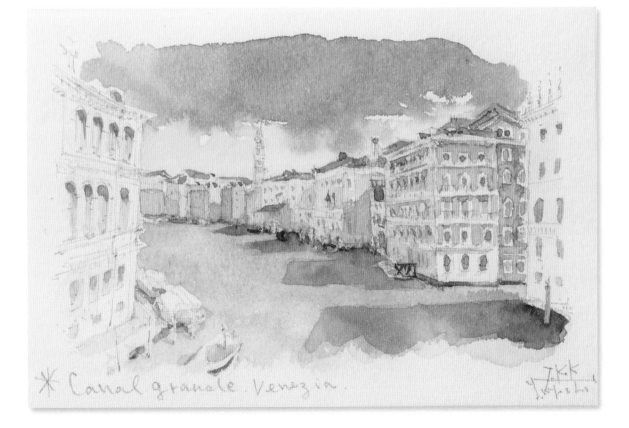

✳ Canal grande. Venezia.

Try Painting Seasonal Postcards

There are times when pictures can convey something more eloquently than words. Why not try sending a picture postcard that matches the season? Add your personal message along with the watercolor sketch.

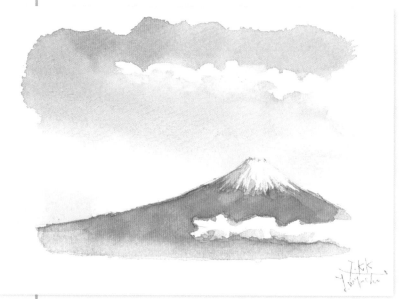

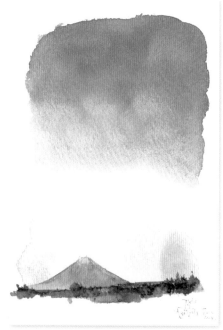

▲ The inspiring form of Mount Fuji makes the perfect motif for New Year's cards. Use the white of the paper to create the snow on the summit and the surrounding clouds.

▲ Color the gradation of the sunrise first, and then add the silhouettes of Mount Fuji and the trees.

◀ Explore Japanese motifs, such as this whimsical arrangement showing beans for throwing at an evil spirit during the Setsubun Festival, held on the day before the beginning of spring. Try using seasonal events as a theme for sketching.

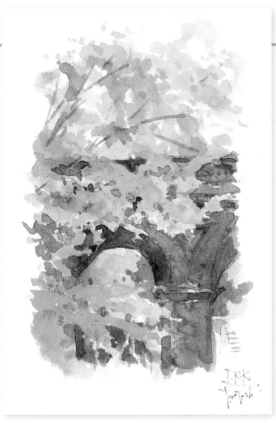

▲ A sketch for early summer with beautiful verdant foliage. By using bold colors, it's easy to give the impression of dazzling sunlight.

▼ If you make a single tree the main focus and paint it all the way to its crown, that towering tree will form the basis of an impressive picture.

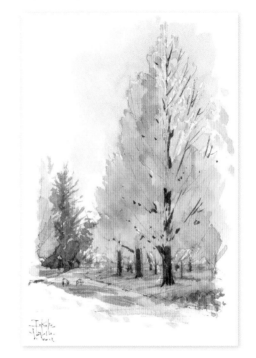

◄ Create a colorful finish, while taking care not to mix the color of the autumn leaves with the blue of the sky.

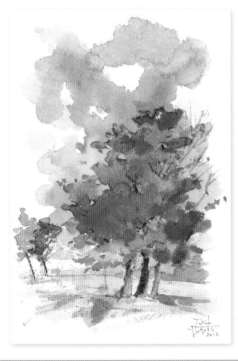

▼ Here is a painting of tree branches that have lost all their leaves, with a clear blue winter sky as a backdrop. Color the blue sky, leaving the areas for clouds uncolored. Then, paint the branches last.

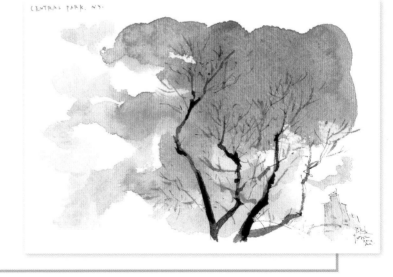

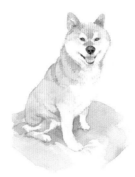

"Books to Span the East and West"

Tuttle Publishing was founded in 1832 in the small New England town of Rutland, Vermont [USA]. Our core values remain as strong today as they were then—to publish best-in-class books which bring people together one page at a time. In 1948, we established a publishing outpost in Japan—and Tuttle is now a leader in publishing English-language books about the arts, languages and cultures of Asia. The world has become a much smaller place today and Asia's economic and cultural influence has grown. Yet the need for meaningful dialogue and information about this diverse region has never been greater. Over the past seven decades, Tuttle has published thousands of books on subjects ranging from martial arts and paper crafts to language learning and literature—and our talented authors, illustrators, designers and photographers have won many prestigious awards. We welcome you to explore the wealth of information available on Asia at **www.tuttlepublishing.com**.

Published by Tuttle Publishing, an imprint of Periplus Editions (HK) Ltd.

www.tuttlepublishing.com

ISBN: 978-4-8053-1748-8

MIZUFUDE PEN DE EGAKU SUISAI SKETCH NYUMON
Copyright © Takako Y. Miyoshi 2018
English translation rights arranged with
TSUCHIYA SHOTEN Co., Ltd.
through Japan UNI Agency, Inc., Tokyo

All rights reserved. The items (text, photographs, drawings, paintings, etc.) included in this book are solely for personal use, and may not be reproduced for commercial purposes without permission of the copyright holders.

English Translation © 2023 Periplus Editions (HK) Ltd
Translated from Japanese by Wendy Uchimura

25 24 23 10 9 8 7 6 5 4 3 2 1
Printed in China 2307EP

TUTTLE PUBLISHING® is a registered trademark of Tuttle Publishing, a division of Periplus Editions (HK) Ltd.

Distributed by

North America, Latin America & Europe
Tuttle Publishing
364 Innovation Drive,
North Clarendon,
VT 05759-9436, USA
Tel: (802) 773-8930
Fax: (802) 773-6993
info@tuttlepublishing.com
www.tuttlepublishing.com

Japan
Tuttle Publishing
Yaekari Building 3rd Floor
5-4-12 Osaki
Shinagawa-ku
Tokyo 141-0032
Tel: (81) 3 5437-0171
Fax: (81) 3 5437-0755
sales@tuttle.co.jp
www.tuttle.co.jp

Asia Pacific
Berkeley Books Pte. Ltd.
3 Kallang Sector #04-01
Singapore 349278
Tel: (65) 67412178
Fax: (65) 67412179
inquiries@periplus.com.sg
www.tuttlepublishing.com

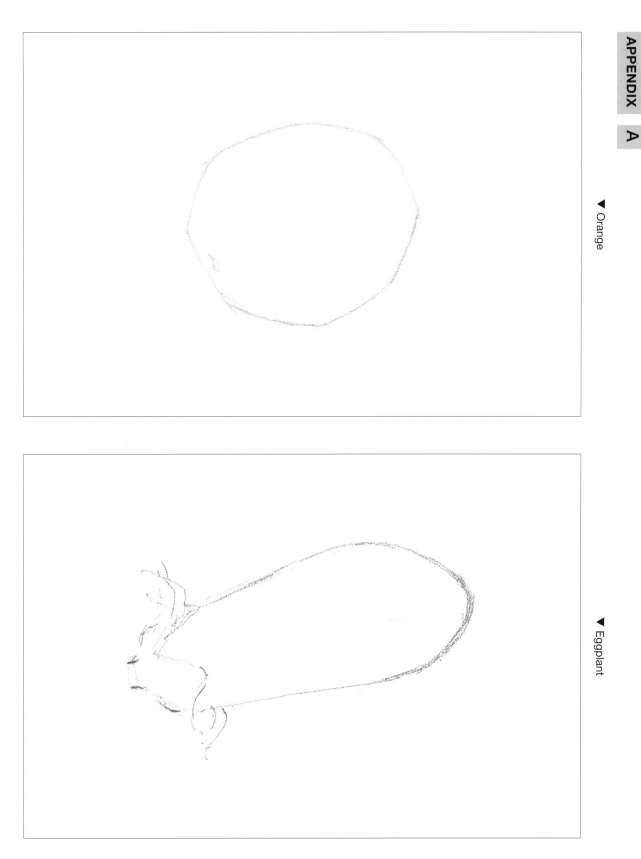

▼ Orange

▼ Eggplant

▶ These are the underdrawings of the watercolor paintings that appear in this book. Although the paper used here is not watercolor paper, you can cut them out, paint on them, and use them as postcards.

Place
Stamp
Here

Place
Stamp
Here

▼ Radish

▼ Cherry Tomatoes and Snap Peas

Place
Stamp
Here

Place
Stamp
Here

▼ Herbs

▼ A Sunflower

Place
Stamp
Here

Place
Stamp
Here

▼ A Rose

▼ A Bouquet

Place
Stamp
Here

Place
Stamp
Here

▼ Coffee and Cake

▼ A Cat

Place
Stamp
Here

Place
Stamp
Here

▼ A Dog

▼ A Child

Place
Stamp
Here

Place
Stamp
Here

▼ Sunset and Sea

▼ Buildings by a Canal

Place
Stamp
Here

Place
Stamp
Here

▼ Cherry Blossoms and a Pagoda

▼ A Cityscape with Depth

Place
Stamp
Here

Place
Stamp
Here

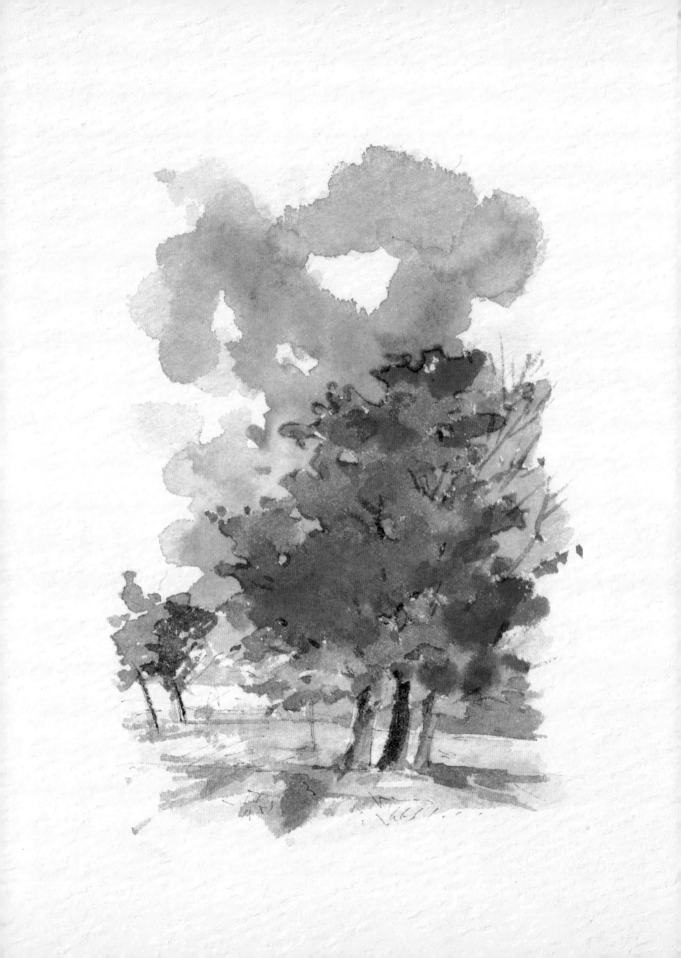